Drawing *for* Beginners

Drawing
for
Beginners

Vadim Koptievsky

photography by Matt Cohen

Sterling Publishing Co., Inc.
New York

Design and layout: Michel Opatowski
Editing: Jennifer Balick

Library of Congress Cataloging-in-Publication Data

Koptievsky, Vadim
 Drawing for beginners / Vadim Koptievsky ; photography by Matt Cohen
 cm.
Includes index.
ISBN-13: 978-1-4027-1261-6
ISBN-10: 1-4027-1261-8
Drawing—Technique. I. Title.

NC650.K67 2006
741.2—dc22

 2005056330

10 9 8 7 6 5 4 3 2 1

Published by Sterling Publishing Co., Inc.
387 Park Avenue South, New York, NY 10016
© 2006 by Penn Publishing Ltd.
Distributed in Canada by Sterling Publishing
c/o Canadian Manda Group, 165 Dufferin Street,
Toronto, Ontario, Canada M6K 3H6
Distributed in the United Kingdom by GMC Distribution Services
Castle Place, 166 High Street, Lewes, East Sussex, England BN7 1XU
Distributed in Australia by Capricorn Link (Australia) Pty. Ltd.
P.O. Box 704, Windsor, NSW 2756, Australia

Printed in China
Sterling ISBN-13: 978-1-4027-1261-6
 ISBN-10: 1-4027-1261-8

For information about custom editions, special sales, premium and
corporate purchases, please contact Sterling Special Sales
Department at 800-805-5489 or specialsales@sterlingpub.com.

Contents

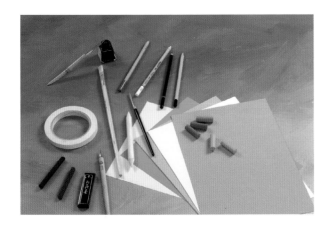

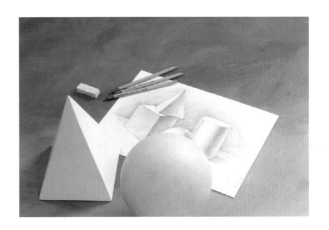

INTRODUCTION 7

TOOLS OF THE TRADE 12
Supply List 14
Paper 16
Drawing Boards and Easels 18
Pencils 20
Erasers and Tortillon Stumps 22
Charcoal 23
Sanguine, Sepia, and White Chalk 24
Ink and Brushes 26
Pastels 28

**LEARNING THE BASICS WITH
PENCIL DRAWING 30**
Choosing a Subject 32
Arranging the Composition 33
Adjusting the Lighting 34
Finding a View 35
Drawing 1: Proportion 37
Drawing 2: Perspective 46

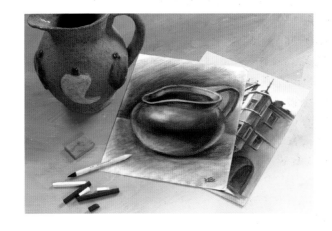

CHARCOAL 62
Drawing 3: Basic Technique 64
Drawing 4: Charcoal and White Chalk
 on Colored Paper 70

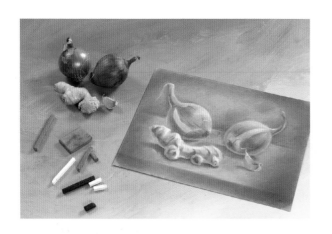

SANGUINE/SEPIA 76

Drawing 5: Three-Pencil Technique 78

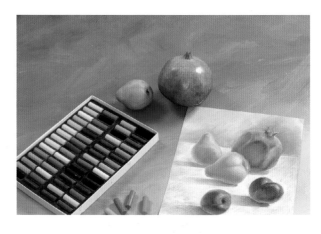

PASTELS 98

Drawing 8: Still Life 100
Drawing 9: Landscape 106

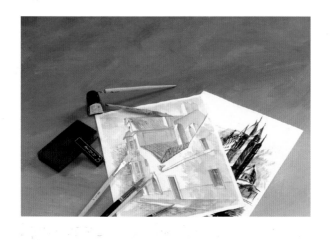

INK 86

Drawing 6: Ink with Soft Brushes 88
Drawing 7: Dry Brush Technique 95

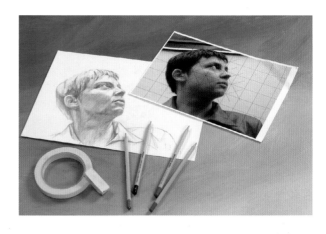

GOING DEEPER 110

Drawing 10: Portrait in Pencil 112
Drawing 11: The Human Body—Quick
　　　　Sketches 121

A FINAL WORD 127

INDEX 128

Introduction

According to family legend, I started drawing at a very young age completely by chance. The year I was three, my mother spent long hours at her drafting table working on her final project as a building engineer—that is, trying to work, between my constant interruptions and pleas for attention! Her solution was to give me a pencil and paper and seat me beside her to draw. And I drew and I drew, long after my mother had graduated with honors, all the way through elementary school, where I began my art studies in earnest at age ten.

The beauty in watching young children draw is their fearlessness. They don't see a white page as a threat, or a finished drawing as a disappointment. They seem to know the moment when a drawing is done, and they happily take a new paper and start on the next. I meet so many people—my students, friends, and even strangers who confide in me—who would love to recapture that joy in drawing. Although they grew up and left drawing behind, drawing never really left them.

That's what led me to start my evening courses in drawing for beginners and, eventually, to write this book. I believe that anyone can learn to draw who is willing to take a chance with a pencil and to open his or her eyes and really see, and my students have proven me right. I hope that the readers of this book will, too.

I continued my art studies in the evenings throughout my school years, when other kids were playing ball and going to movies. I studied drawing, painting, and sculpture, and by the end of high school I was ready to delve deeper and find my own style. After art college, I continued my training in illustration and graphic design. I worked as an illustrator and an architect and designed for performances. And always, I drew and drew.

Although drawing is the basis for many forms of art, such as painting and sculpture, it is a complete and fascinating medium in itself. The drawings of famous artists, for example, aren't "just sketches." They are finished works on their own—all the more beautiful because of their cleanliness and clear shapes.

In much the same way that photographers and filmmakers often love to work in black and white, many artists are partial to drawing in pencil, charcoal, or ink. Color can actually get in the way of seeing the play of light and shade, the richness of tones, and the delicate shades of gray.

In earlier times, before photography, almost everyone drew. They drew pictures of family members, they drew their own "snapshots" of places they visited and, in the absence of all the entertainment we have today, they drew just for fun! In those days, people realized that drawing is just another skill that you can learn with some training. When did we start thinking that only "artists" can draw? The truth is that if you can learn to cook, or drive, or do so many other things you take for granted, you can learn to draw.

One of my evening students is a neighbor who never thought he would pick up a pencil and draw. He is, by the way, now part of a class that has been with me for five years and is producing beautiful work. One day we were having coffee in his living room, where his two small daughters were sprawled on the floor drawing, sheets of paper, crayons, and markers spread all around them. "I can't help them at all," he said, frustrated. "I don't know how to draw things myself, like where the sky meets the land, or

How to Use This Book

1. Check the Supply List (pages 14–15) first. It shows you everything you'll need.

2. Draw your way through the book from beginning to end, completing the projects in order.

3. Pay special attention to the tips in the "Key to Success" boxes.

4. Try the "Just for Fun" boxes. You'll be surprised at what you can do!

how perspective works. I know I have it in me, but I feel held back." "What is it that's holding you back?" I asked him. "Is it that you don't know how to draw, or that you want to learn and just haven't done it yet? Either way, my classes are full of people who were just like you."

My evening students have no formal drawing background whatsoever. Many work at computer screens all day and long for something more free and creative. Others are executives who never realized a childhood dream of being an artist. Some have found that drawing helps their careers, because they're better able to sketch their ideas in marketing, advertising, fashion, and other such fields.

I know, however, that not everyone can get to an art class. It takes time to find a course and money to pay for it. It's hard to make schedules match. And some people, as I've been told many times, would rather work in the privacy of their home and not attempt drawing for the first time in front of a class.

Assuming you're just one of those people, I've written this book to mirror my classes, but with exercises that are tailored for people at home with only this book as their guide. Take a look through the pages—you'll see that the system is built on clear and simple steps that will help you get results quickly and, I hope, be encouraged by your success to practice and improve.

I invite you to take control of the pencil, trust your eyes, and believe that you can draw. You'll always work with subjects that you choose—still lifes that are right in front of you—so that you can check your drawings against them and see if you're headed in the right direction. Because you'll be able to draw objects that have meaning for you, such as a favorite mug or an ornament with memories, you'll be motivated to make it right, to make it true. You'll be able to say, "I didn't draw just any mug. I drew this one."

Once you begin, you'll start seeing the world in a different way. You'll notice beautiful compositions, light and shade, interesting details. . . . The more you notice, the more you'll want to draw! Keep a drawing pad with you and practice when you have a few minutes or when the beauty of a scene strikes you. Let drawing become a part of your life. You just may find that it takes you where your heart has always wanted to go.

Just for Fun

After you've tried the exercises once or twice, you can experiment with different tools and materials. You'll discover new effects on paper that will delight you, and you just may find the technique that you'll want to define as your own!

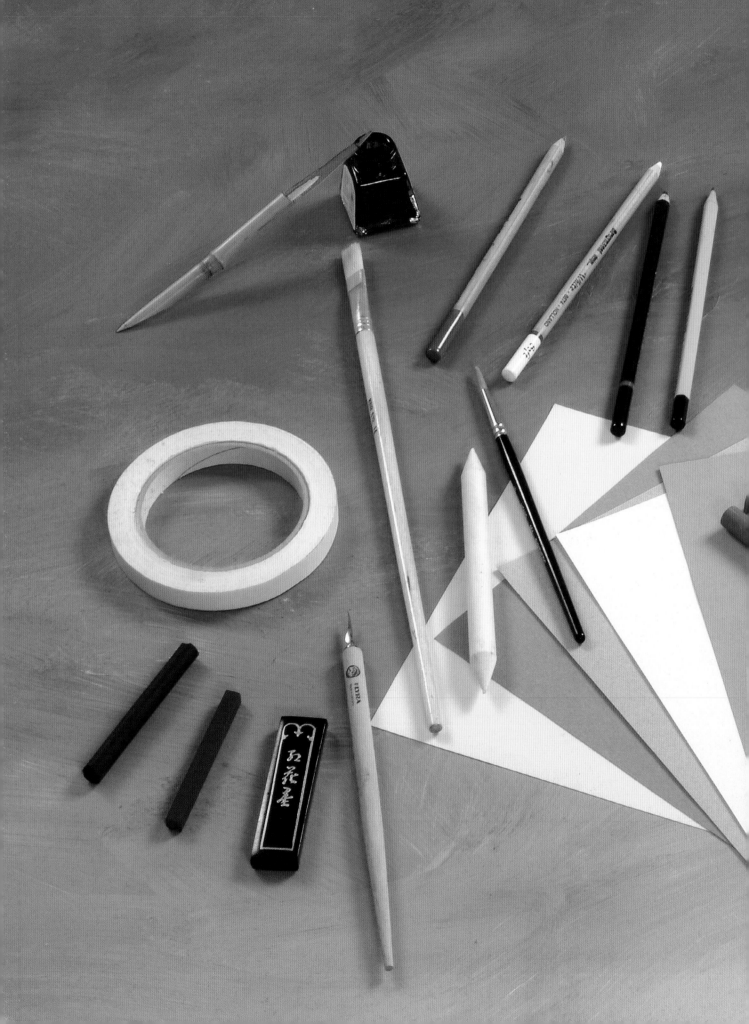

Tools of the Trade

All you really need to start drawing is a pencil, paper, and a clipboard or easel. On the other hand, you can use more professional materials that will help you achieve remarkable results (with a little bit of guidance).

My beginning students often make the mistake of running eagerly to the nearest art supply store before the course starts and trying to choose supplies—only to be overwhelmed by all the choices and walk out empty-handed.

In this chapter, I'm going to make sure that doesn't happen to you. I'll provide you with a list of the bare essentials, including paper, pencils, charcoal, sanguine, chalk, brushes, pens, ink, and pastels. We'll also talk briefly about how to use them, so that you can succeed in all the exercises in this book.

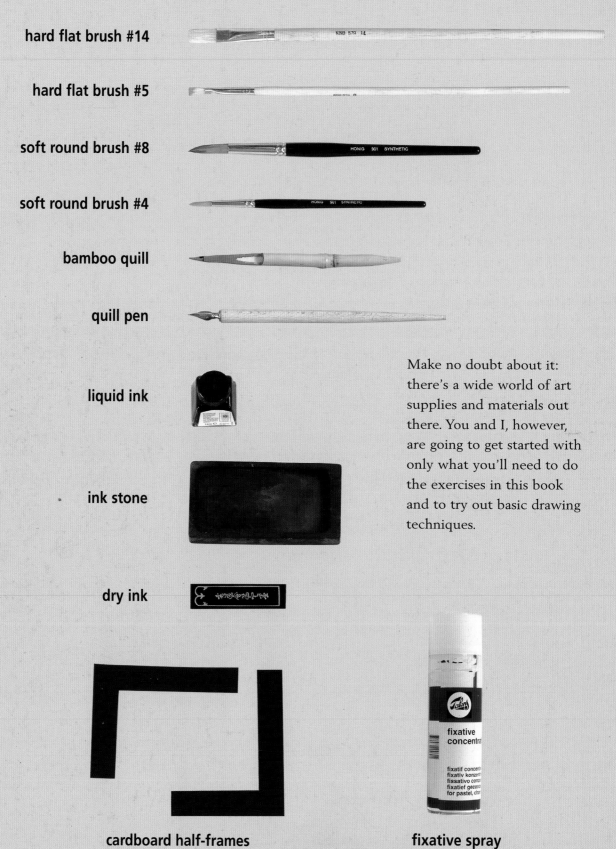

hard flat brush #14

hard flat brush #5

soft round brush #8

soft round brush #4

bamboo quill

quill pen

liquid ink

ink stone

dry ink

Make no doubt about it: there's a wide world of art supplies and materials out there. You and I, however, are going to get started with only what you'll need to do the exercises in this book and to try out basic drawing techniques.

cardboard half-frames

fixative spray

.ist

You can easily buy the items shown here in one trip to the art supply store. If you'd rather buy the items separately as you proceed through the book, however, no problem! Just check the What You'll Need list at the beginning of each drawing.

In this chapter, you'll find pictures of all the supplies and some pointers on how to use them.

HB pencil

2B pencil

normal eraser

kneadable eraser

tortillon stump

charcoal stick

charcoal pencil

sanguine stick

sanguine pencil

sepia stick

sepia pencil

white chalk stick

white chalk pencil

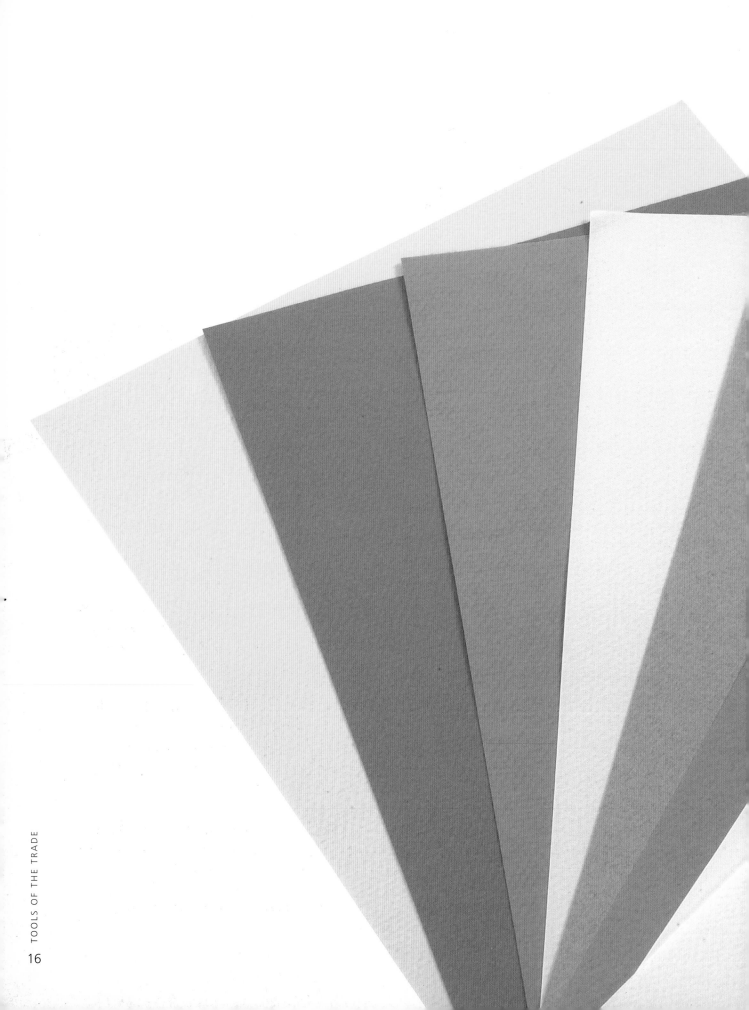

Paper

Although you can draw on any kind of paper, you'll get the best results with the high-quality, textured drawing paper sold in art supply stores. It's the texture of the paper that brings pencil, charcoal, and pastel to life.

We'll use different textures with different materials. For each exercise in the book, I'll tell you what texture to use. For example, a fine texture is best for pencil; a medium texture is best for charcoal, pastels, and sanguine; and a rough texture is best for ink and brushes.

We'll use both white and colored drawing paper. Colored paper, especially in the light brown or gray hues, is wonderful for work in charcoal, chalk, and pastels.

You can buy paper in single sheets, drawing pads, or rolls.

Drawing Boards and Easels

Have you ever wondered why artists work at easels? The main reason is to keep all parts of the paper at the same distance from their eyes. Think about it: if you work at a table, the top part of the paper will be farther away from you than the bottom, creating distortion in your drawing. When you hold it up and look at it, you'll see that you drew the top part too large in order to compensate for the distance.

So you need to be able to work on a hard surface and to keep your drawing upright. How? By using an easel or a drawing board. It's your choice, and it depends on whether you want to work standing up or sitting down. The important thing is to be comfortable.

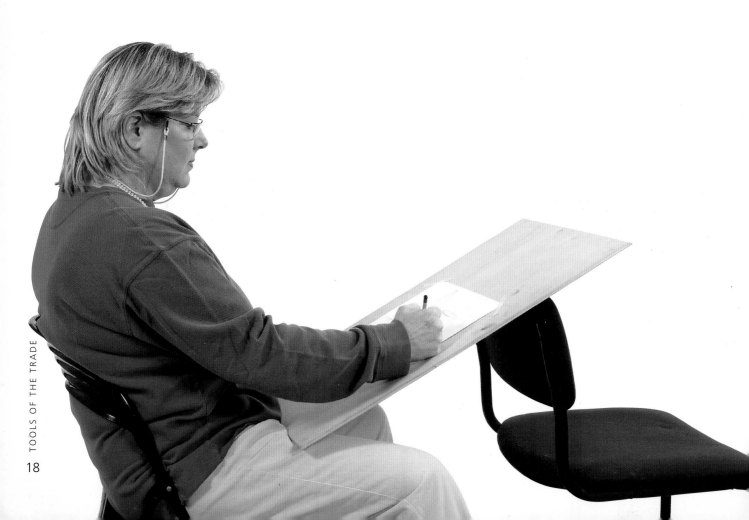

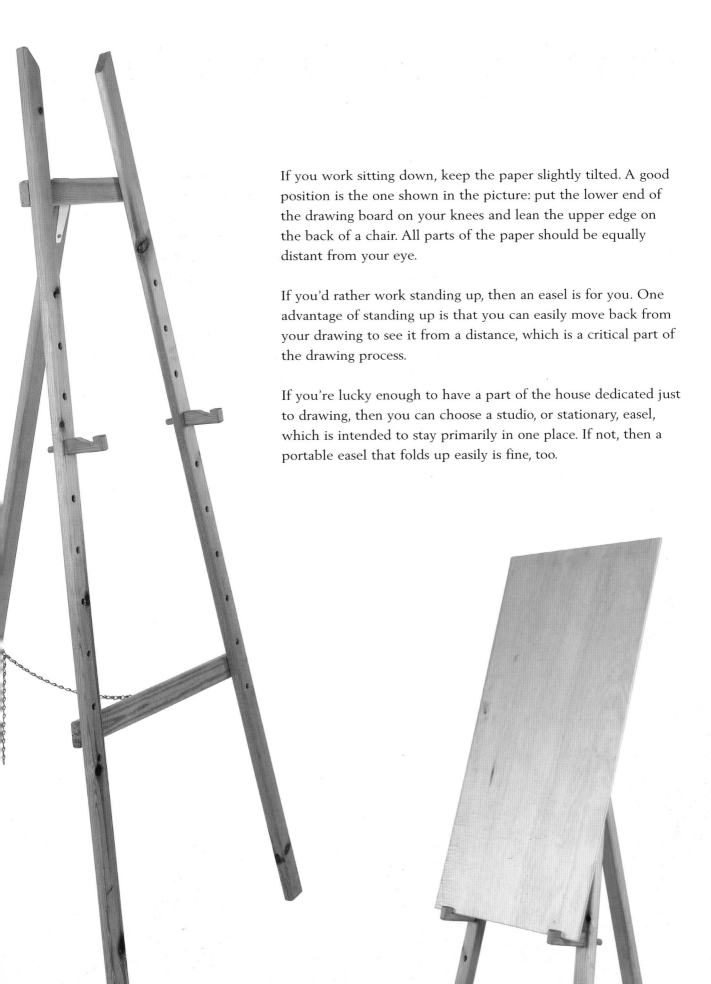

If you work sitting down, keep the paper slightly tilted. A good position is the one shown in the picture: put the lower end of the drawing board on your knees and lean the upper edge on the back of a chair. All parts of the paper should be equally distant from your eye.

If you'd rather work standing up, then an easel is for you. One advantage of standing up is that you can easily move back from your drawing to see it from a distance, which is a critical part of the drawing process.

If you're lucky enough to have a part of the house dedicated just to drawing, then you can choose a studio, or stationary, easel, which is intended to stay primarily in one place. If not, then a portable easel that folds up easily is fine, too.

Pencils

After using this book, I guarantee that you'll have a newfound respect for the lowly pencil. Pencils are deservedly the most popular material for drawing and come in a wide range of softness and effects. In this book, I'll guide you on which pencils are best to use for effects such as thin lines, hatching for shading, and dark hues.

The most common pencils for drawing are:

HB (or **F**) pencils	**medium**
B pencils (from **B** to **8B**)	**soft**

By the way, you may also see **H** (from **H** to **8H**) pencils in the store. These are the hardest type of pencil and are used mainly for drafting, not for drawing.

For the exercises in this book, I recommend that you buy one or two each of the following types:

HB or **B** pencils	For the **first steps** in a drawing
2B pencils	For work with **light and shade**
5B pencils	For intense, **dark hues**

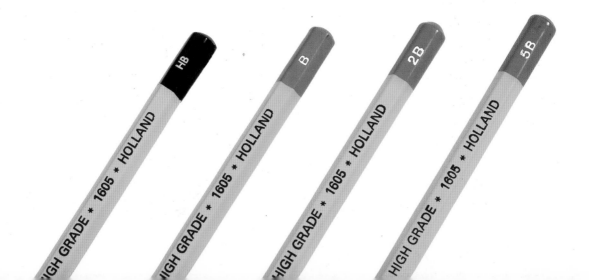

HB B 2B 5B

Just for Fun

When you've finished the pencil drawings later on in the book, try them again with some of the pencils that you see illustrated here, such as watercolor pencils, graphite sticks, and mechanical pencils. You'll see how different tools can give you a whole new effect.

Erasers and Tortillon Stumps

kneadable eraser

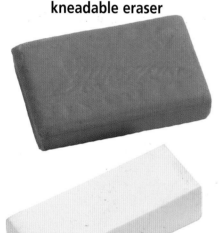

tortillon stumps

normal eraser

You'll need two types of eraser: a kneadable, or putty, eraser and a good, normal eraser.

Erasers, by the way, have an important job beyond just erasing mistakes. They can be used to lighten or soften areas of a picture. Remember being in first grade and erasing so hard that you went through the paper? Over time, you learned how to erase gently, a skill that will come in handy now. When you draw, use erasers very carefully to keep from destroying the paper.

A tortillon stump is basically a stick with pointed ends made of rolled paper. It's used for blending pencil, charcoal, sanguine, and pastels. You can use it to soften shading in order to achieve the tone that you want. Usually you'll work with two or three stumps of different sizes and use both ends, one for darker areas and one for lighter.

I use the stump at times, but I use my fingers or the palm of my hand, too. As you start to draw, you'll find out what works for you.

Charcoal

When you draw with charcoal, you're joining a tradition of artists that dates back to ancient Greece and beyond. The forms of charcoal we'll use are natural charcoal, which is much like a burned piece of wood, and synthetic compressed charcoal. Natural charcoal is made from the controlled burning of small branches and twigs. Compressed charcoal, which comes in sticks or pencils, makes a darker, more intense black. The pencils make finer lines and less of a mess than the sticks.

Although charcoal is available in soft, medium, and hard forms, we'll use only soft charcoal in this book.

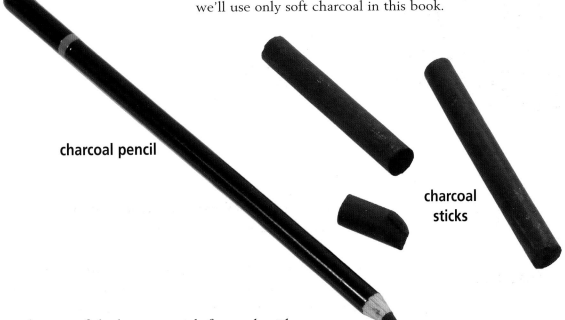

charcoal pencil

charcoal sticks

Charcoal is one of the best materials for work with large areas of light and shade. When you begin the charcoal exercises in this book, you'll be amazed at the wide range of hues you can achieve. My students are always surprised that there are so many shades of black!

You can blend charcoal easily because it does not adhere strongly to paper. Compressed charcoal adheres to paper better than natural charcoal, but you can spread or lighten either one with a tortillon stump, a kneadable eraser, or your finger.

No matter what kind of charcoal you use, you must use a fixative spray to protect the drawing when it's finished.

Sanguine, Sepia, and White Chalk

Take one look at a sanguine and you'll know why its name comes from the French word for blood. Its pigment contains iron oxide which, in nature, occurs in hues from brown to red.

Although the technique used with sanguine is very similar to that of charcoal, you'll feel the difference in the way sanguine adheres to paper and will learn to love its subtle tones—the darkest tone it can make is still much lighter and more luminous than charcoal black.

Renaissance artists commonly drew with sanguine, including Michelangelo, Raphael, and Leonardo da Vinci, who used it in his sketches for *The Last Supper*.

Sanguines are sold as pencils or as sticks. You can use the sticks for larger surfaces and the pencils for detail work.

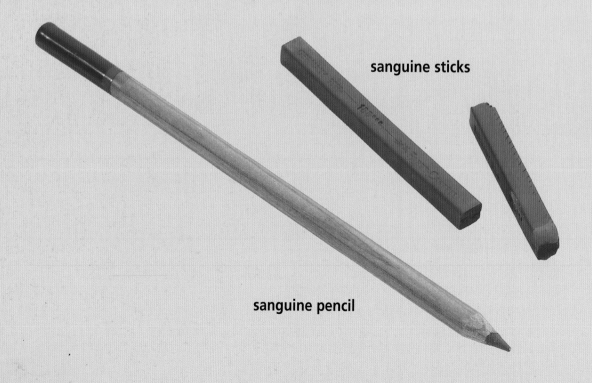

sanguine sticks

sanguine pencil

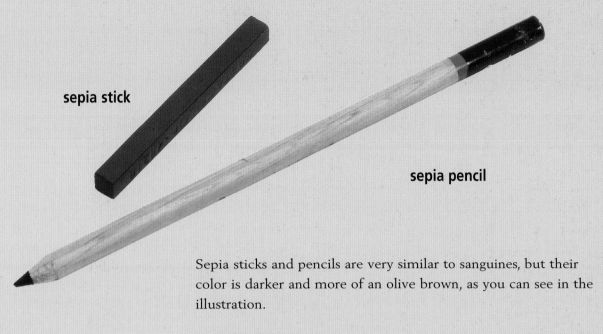

sepia stick

sepia pencil

Sepia sticks and pencils are very similar to sanguines, but their color is darker and more of an olive brown, as you can see in the illustration.

White chalk for drawing can be round or rectangular. It also comes in pencils.

Later on we'll do an exercise using the Three-Pencil Technique (page 78), which combines sanguine or sepia, white chalk, and charcoal. This technique was especially popular in 17th- and 18th-century France among artists such as Antoine Watteau.

white chalk pencil

white chalk sticks

Ink and Brushes

Drawing with brush and ink immediately calls to mind the beauty of Chinese landscapes and calligraphy. The technique dates from the third century B.C. in China, and from there spread throughout East Asia, especially to Japan and Korea. Chinese calligraphy, with its wide range of expressive brush strokes, has shown over time that magnificent, lasting art can be created with nothing more than ink, a brush, and paper— exactly what we'll be using in this book.

There are two basic types of ink and two basic types of brush:

Dry ink comes in a block that you use with an ink stone. To use it, you have to make an ink solution by mixing the ink powder with water. First you put water into the tub of the ink stone and then you scrape the ink against the stone so that some falls into the water. You can add more or less water, depending on how dark or light you want the ink to be. (Note that dry ink is also sometimes called Chinese ink.)

Liquid ink is ready to use right out of the bottle. I recommend using black India ink, but you can also use any other type of black liquid ink. Like dry ink, liquid ink can be mixed with water to create shades of gray.

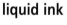

liquid ink

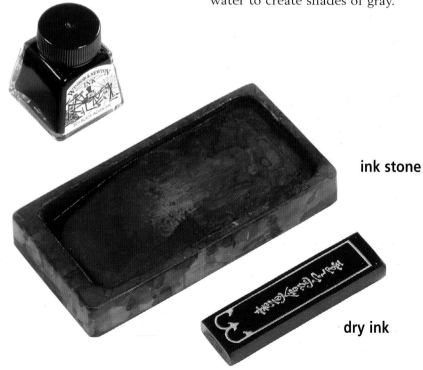

ink stone

dry ink

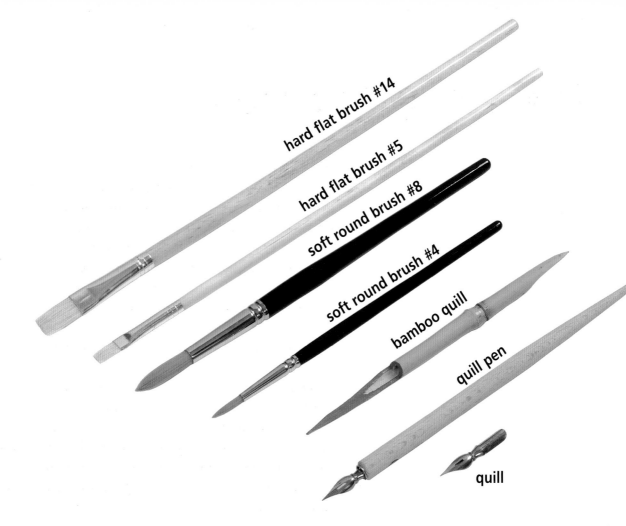

hard flat brush #14

hard flat brush #5

soft round brush #8

soft round brush #4

bamboo quill

quill pen

quill

Soft brushes are also called watercolor brushes. We'll use round brushes, which are full and come to a point. Unless you buy the most expensive kind, it's a good idea to check the quality of a brush before you buy it. Otherwise, hairs might fall out of the brush and stick to your drawing. Wet the brush a little bit and see if all the hairs gather together into a clear point. If they do, then it's a good brush.

Hard brushes (also called hog's hair brushes) are flat and don't come to a point. You can check the quality of a hard brush the same way you check your toothbrush: the bristles should be densely packed together, forming a straight, even edge and not fanning outward.

Quill pens are used for adding fine details to ink drawings. They come in a variety of materials, including metal, reeds, and bamboo.

Pastels

Pastels will enhance your drawings with the power and beauty of color. Named for the paste that is created by mixing chalk and pigment, pastels are available in a breathtaking range of hues. Sets can include as few as 12 and as many as 552 colors. I recommend that you begin with a set of 24 or so.

Keep in mind that you don't need to buy every color under the sun, because you can make your own! The magic of pastels is in the blending—put lighter colors over darker ones and spread and blend them with your finger to get different hues, subtle tone changes, and fine gradations.

Pastels are beloved for their luminous colors and the sparkling effect that results when light reflects from the tiny particles that form the surface of a pastel drawing.

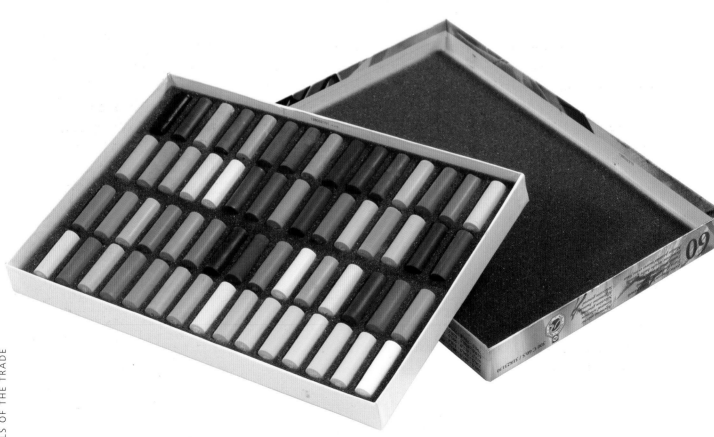

The technique flourished in France, where it began in the 18th century and was brought to its greatest heights by Edgar Degas a hundred years later. Degas experimented with ways to bring out the effects of light and shade with the medium, pioneering many of the techniques that you'll use later in this book, such as using crosshatch lines, textured paper, and even fixatives.

Pastels adhere easily to paper and make a soft, smooth mark. For the most effective results, use colored paper of medium or rough texture. To make corrections, you can use a kneadable eraser or clean cloth.

Always use a fixative on your finished drawing.

By the way, be careful not to confuse soft pastels with oil pastels. Oil pastels are a different medium entirely, which we won't be using in this book.

Just for Fun

Pastels also come in pencil form. When you get to the pastel exercises in the book, try them! The pencils make finer lines, so you can draw more detail. And, as with the charcoal pencils, you'll get less dirty, too!

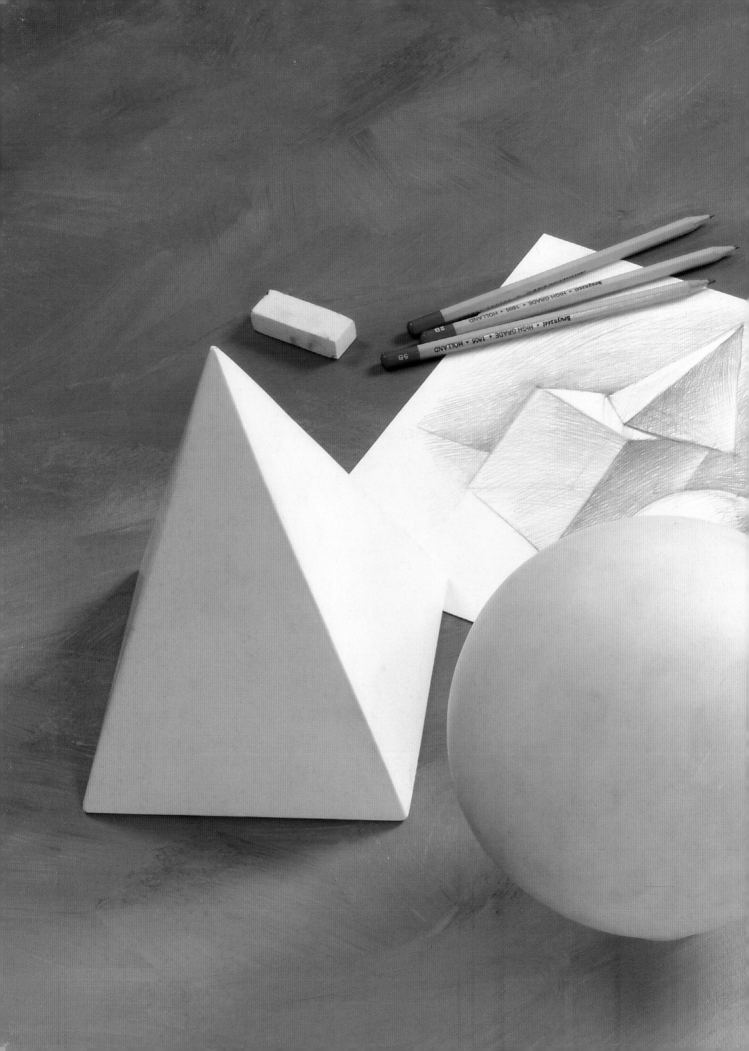

Learning *the* Basics
with Pencil Drawing

Drawing, like any other skill, is based on fundamentals. Once you have these essentials in hand, you're on your way. In this chapter, we'll talk about choosing a subject, arranging your composition, proportion, perspective, and light and shade. These are the keys to making your drawings look alive and real.

Believe it or not, just a pencil or two will take us through this first part of our journey. The soft drawing pencils recommended in this book offer a wide range of possibilities. They make beautiful and varied shadings and gradations—some of which you can achieve just by blending with your finger.

Choosing a Subject

Make your drawings your own by choosing subjects that are beautiful to you. You can choose objects that have special memories or associations, or simply everyday things whose natural beauty catches your eye. If you don't find your subject interesting, then the work will seem pale and devoid of feeling, no matter how polished your technique.

For your first drawing, choose several objects to combine into a still life. Walk through your home and look around. Try to choose items that have clear shapes and different sizes.

You'll be surprised at how many common objects are striking in ways you don't usually notice. A ceramic pitcher, a few pieces of fruit, a bottle—lovely pictures are all around you, just waiting to be drawn.

Put the objects you've chosen on a smooth, light-colored surface, such as a table with a light tablecloth. The background is important, too: a plain, light background, such as a white wall, is best.

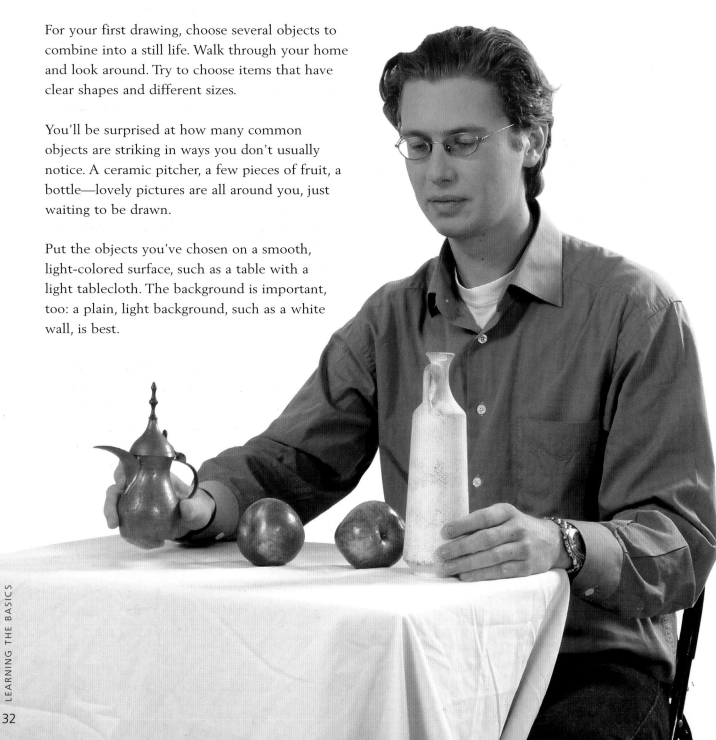

Arranging the Composition

Arrange the objects so that they're neither cluttered together nor isolated far apart. Here are two typical mistakes to avoid right from the start:

1 Two objects, one behind the other, that "blend" into one:

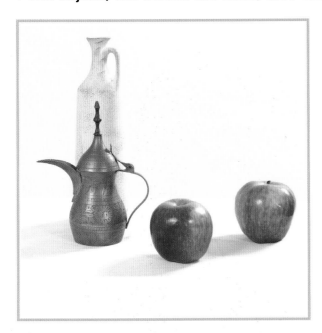

Have you ever taken a snapshot where someone in the picture has a tree "growing" out of his or her head? This happens when the imaginary line that runs up and down through the middle of the person is lined up exactly with the line that runs up and down through the middle of the tree. When we see this, the two objects seem to blend into one.

In your composition, make sure that no object is centered exactly in front of another. Move one a little to the side. In fact, try to make sure that all the objects slightly overlap one another.

2 Two objects, side by side, that "blend" into one:

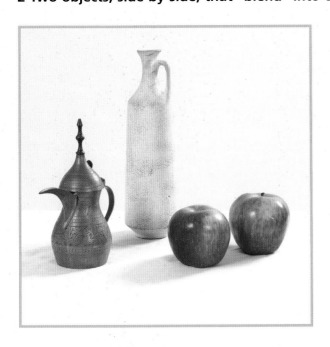

Two objects whose sides seem to touch can look like one oddly shaped unit! Make sure that the side of one object does not reach exactly to the side of another. This can happen even if the objects are not actually touching. For example, one object may actually be behind the other, but if the side of one lines up exactly with the side of the other, then they will seem to be joined when you look at the composition from a distance.

Make sure either that you clearly see the gap between the two objects, or that they overlap each other.

Adjusting the Lighting

You can light your still life with either sunlight from a window or artificial light from a lamp. Either way, place the objects so that the light reaches them from somewhere between the side and the front, not directly from either. Play with turning the objects and looking at them until you find the lighting that best brings out their shape and volume.

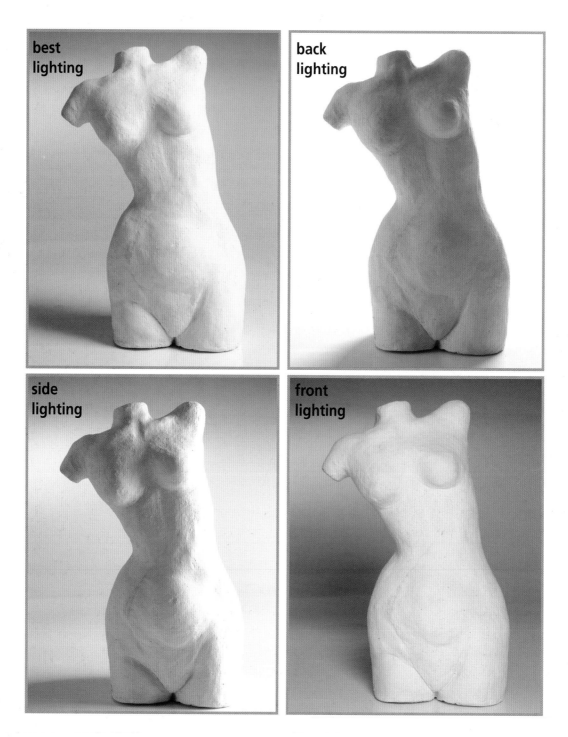

best lighting

back lighting

side lighting

front lighting

Finding a View

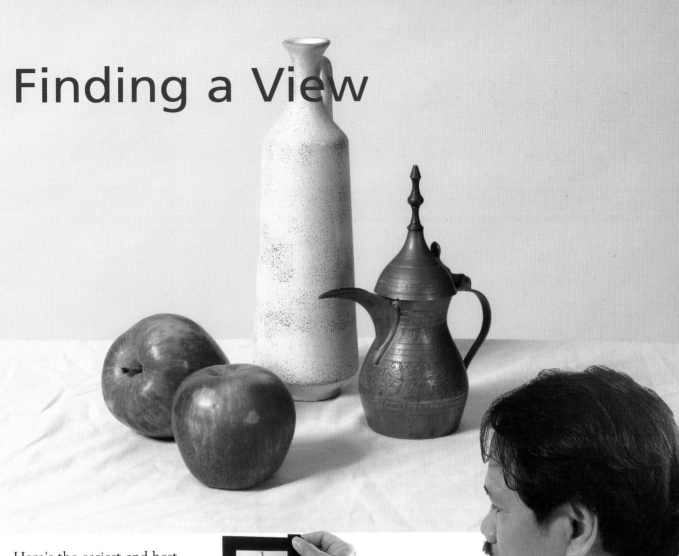

Here's the easiest and best way to see how your composition will look on paper: you'll need a black cardboard frame that is made from two separate pieces, each one with two sides of the frame at a 90-degree angle, as shown in the picture.

Look at your composition through the frame, making the opening the same shape as your drawing paper, either square or rectangular. Move around until you find the exact view from which you'd like to draw your subject, then place your chair (if you're using a drawing board) or your easel on that spot.

As you look through the frame, pay close attention to how the objects are placed and make sure that you're satisfied with the composition. Is it too cluttered? Are the objects too far apart? Make any adjustments that you need. Don't forget to check for any objects that appear to be joined together as one.

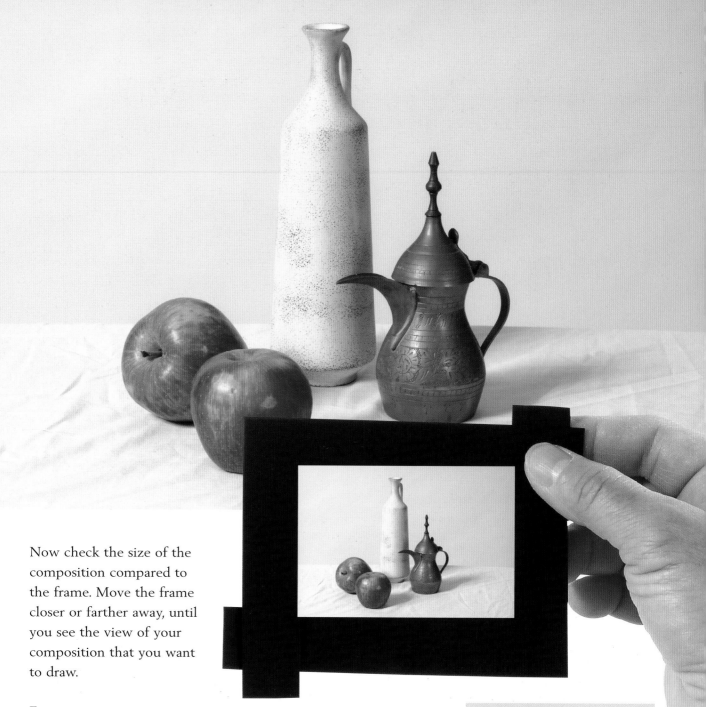

Now check the size of the composition compared to the frame. Move the frame closer or farther away, until you see the view of your composition that you want to draw.

For some reason, my beginning students tend to "shrink" the composition into the center of the frame, leaving too much blank space around it. Don't be afraid to let your composition fill the paper!

Remember, you don't have to memorize the placement that you've chosen. As you draw, you can keep using the frame to check the composition until you've finished drawing the outlines of all the objects on the paper. Just pick it up and have another look.

Just for Fun

Here's another way to use the cardboard frame: instead of creating your composition beforehand, try looking around you through the frame and choosing a composition that occurs naturally.

Drawing 1: Proportion

What You'll Need

- Drawing board or easel
- Fine-textured, white paper, 9" x 12"
- HB and 2B pencils, well sharpened
- Kneadable eraser
- Normal eraser

For your composition, you've chosen a pitcher, a coffeepot, and two apples and placed them on a white tablecloth. Remember to arrange your composition on a light surface and background and then check the placement of the objects and the lighting. Use the cardboard frames to choose the view and size of your still life.

It's time to take pencil in hand, but we're not going to draw just yet. You'll use the pencil and your thumb to take the "measurements" of your composition. This is where you learn how to handle proportions: to make sure that the objects in your picture, and the distances between them, are in correct proportion to one another.

This method is a favorite of my students because it's easy to learn and it really works! We've all seen drawings where one object looks out of proportion to the others—it could be a huge apple, a towering bottle, etc. This will help you avoid making that awful mistake. It may take you a few tries to get the hang of it, but you'll be richly rewarded when your drawings look balanced and real.

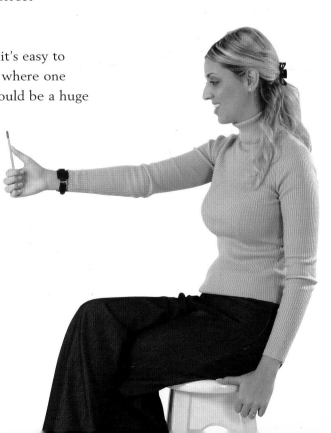

MEASURING PROPORTIONS

1 Choose one of the objects to be your standard—the one you'll compare all the others to. It should be entirely visible, meaning not partially hidden by something else.

For the example in the picture, choose the coffeepot.

2 Decide if you want to use the object's height or its width as your standard.

Choose the coffeepot's height.

3 Hold the pencil straight out in front of you and raise its point up to your eye level, keeping your arm straight at all times. (This guarantees that you always measure at the same distance from your eye.)

4 To measure the height of the object you chose, close one eye, point the pencil at the top of the object and, with the tip of your thumb on the pencil, mark the bottom of the object.

If you chose to measure the width of the object, point to one side of the object, holding the pencil horizontally, and mark the other side with your thumb.

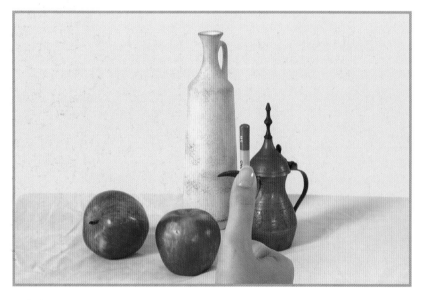

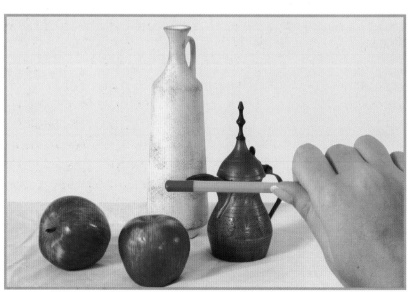

5 Now you have your standard measurement—the distance from the pencil point to your thumb. As you begin to draw the outlines of your objects, you can always quickly take your standard measurement again and use it for comparison.

How? Take your standard measurement and then, keeping your thumb in the same place, measure the height or width of another object.

For example, you may find that a bottle is twice the height of your standard, or that the width of a pear is half the height of your standard.

6 Don't forget that you can also measure the distance between objects. For example, the space between two items may be the same as (or two-thirds of, or half, etc.) your standard.

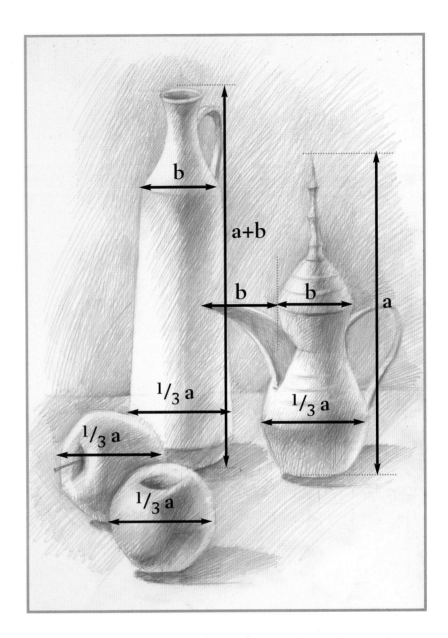

The diagram shows how the objects in the composition, and the distances between them, compare to your standard measurement. For example, the width of the apple is one third the height of the coffeepot.

The most important time to use this method is at the beginning, when you draw the outlines of the objects in your picture. Don't think of these measurements as something you have to write down. As you get more practice, you'll be able to check them almost automatically.

This method is mainly for checking and correcting. Here's a bit of wisdom from me to you: Try not to get too caught up in the measurements—trust your eyes!

Congratulations! If you've reached this page, then you've got your pencils and erasers ready and you've attached your paper to an easel or drawing board. You've arranged your first composition, checked the lighting, and chosen a view of your still life using cardboard frames.

Now here's another word to the wise: Be sure to keep your hands clean. Believe me, there's nothing more frustrating than smudging a picture you care about.

On to the drawing!

 In this step, you'll get the initial outlines of your drawing onto the paper. Take an HB pencil and draw a first outline of each object in the composition. Relax, draw with confidence, and just have fun—HB pencils make thin lines that can be erased easily, so you can make corrections later if you have to. Try not to press too hard as you draw.

When you've drawn all the outlines, use the cardboard frame to make sure the composition you've got on the paper matches the one you chose earlier. If you've drawn the composition too big or too small, then correct the drawing by erasing with the normal eraser.

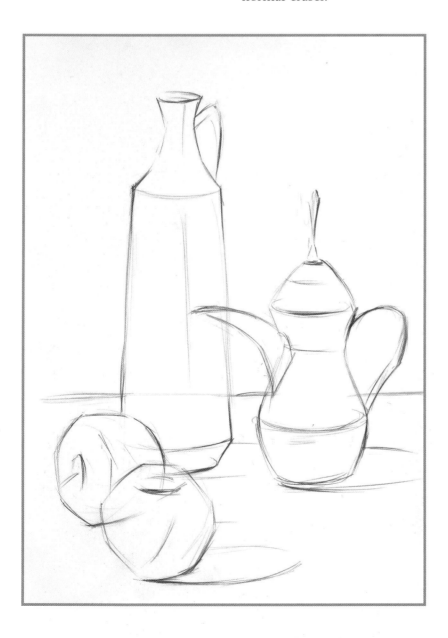

Keep in mind that the first lines you draw are valuable, too. They can be your guide to making corrections and getting it right the second time around.

As you work, you can also draw in the outlines of any shadows that fall on the table surface.

Now you'll make the outlines more precise and create areas of light and shade. Check the proportions with the pencil and your thumb and make any corrections that you need using the eraser. If you have symmetrical objects, such as a pitcher or a bottle, it helps to draw a vertical line through the center from top to bottom and then correct the shape as accurately as you can. Afterwards draw in any details, such as handles, spouts, or labels.

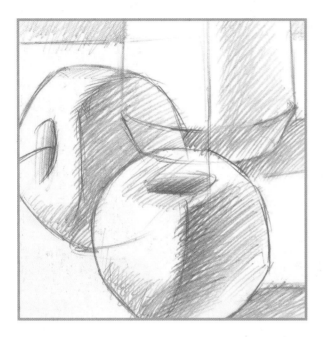

Begin to create areas of light and shade by drawing hatching lines to make shaded areas darker. The direction of the hatching lines is not important. (In fact, the way to further darken an area you've shaded is to change the direction slightly and draw more lines on top of the first ones. This is called "cross hatching.")

The important thing in shading is to draw quick, free lines. Sometimes I see my beginning students laboriously drawing even, parallel lines. This not only takes a lot of time, but the result also doesn't really look like shade.

As you create more and more areas of shade, you'll see a wonderful thing happen on the parts of the object that you leave white: they'll seem to take on light in contrast!

Have you ever noticed that there are really no outlines in nature? Things don't have dark lines around them that are "colored in." We perceive objects as areas of light and shade and, as you continue to draw, you'll not only become more and more aware of this, but also more able to recreate the effect. Achieving the right play of light and shade is the most important goal in drawing.

Keep working on the entire picture at the same time, rather than concentrating on any one spot, so that the whole picture gradually "comes off" the paper. This is an important habit to learn and one that I'll remind you of as we go along. It helps you make sure that your areas of shade have the right relationship to one another.

For example, I've watched students get so caught up in an area of shading that they make it very dark, only to realize later that it should have been just a middle tone.

Key to Success

Move away from your drawing often to look at it from a distance. This helps you see the picture as a whole and notice where you may have over-emphasized areas of shading or detail.

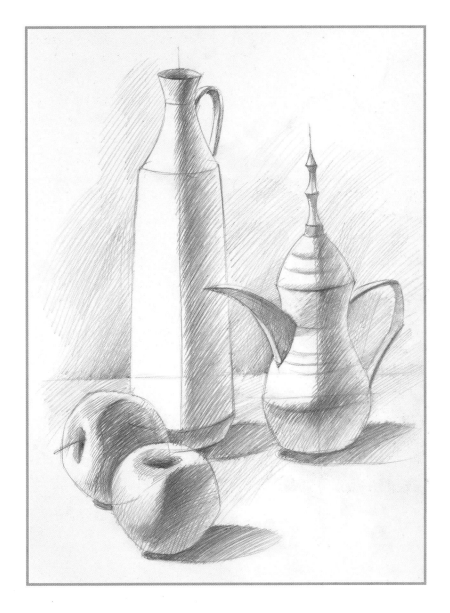

3

In this step, you'll begin to reinforce the contrasts between light and shade by making areas with deeper shades and shadows.

Using the same pencil, darken the shade where necessary by drawing another layer of quick hatching lines in another direction.

You can also start drawing the areas of shadow that you see in the background and on the table surface. Compare the two carefully: notice where the shadow on the background is darker or lighter than the shadow on the surface. As always, keep your eye on the relationship between areas of shading.

Have you noticed that you don't have to erase the original outlines and vertical lines that you drew? These get blended in automatically as you develop the shading in the drawing.

Now it's time to pay special attention to the darkest and lightest places in the drawing.

Using the softer 2B pencil (which makes blacker marks), draw more hatching lines where you need them to create the darkest areas of shade.

You can also use the kneadable eraser as a drawing tool here. Use it to lighten areas of shading that you may have drawn too dark. If you've shaded areas that should be lit, lighten them with the eraser as much as you can.

If you can see any of your original outlines—they'll probably show up in a light area—then erase them now. You can see that the vertical line that appeared in the lit part of the pitcher has been erased.

As you work, keep your eye on the shapes and don't get caught up in the details of any one object. A detail that is highlighted too strongly, such as a label on a bottle or the intricacies of a flower, can make the object itself look "flat" and undo all the important shading work you did to give it depth and volume.

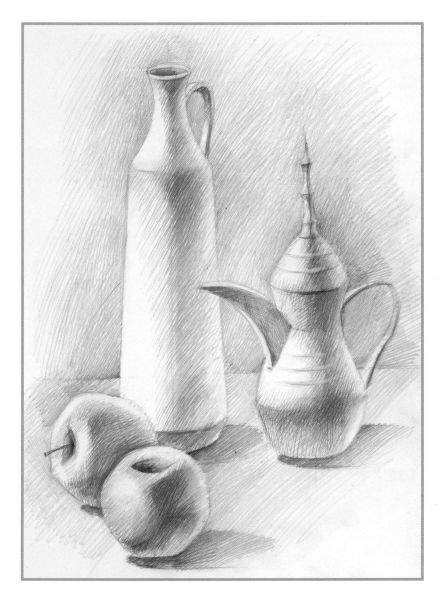

Take a step back and look at your composition; try squinting and letting your vision get a bit out of focus. The small details that are not important disappear, and you see only the general relationships between light and shade.

Now look at your drawing: have you achieved that same effect in your picture? It's a good idea to step back and make this comparison frequently as you draw. You'll see that it will soon become a habit.

If you have a detail in your drawing that seems too bold, you can try one of two things: either use your kneadable eraser to lighten it, or cover it with a layer of hatching lines to blend it in with the drawing. Take your pick and give it a try!

You've completed your first pencil drawing and learned important fundamentals along the way. Ready to move on?

Drawing 2: Perspective

If I had to choose the lessons that my beginning students value the most, it would be the ones about perspective. So many people come to my course having tried to draw on their own and given up in frustration, because they saw that the perspective in their drawings wasn't right and they didn't know how to fix it.

That's not going to happen to you. Understanding perspective is not hard and, like anything else, just takes a little practice. Without getting into mathematical formulas, I'll pass the most important points on to you so that you can begin to draw pictures that are true to life, pleasing to the eye, and a source of pride.

What You'll Need

- Drawing board or easel
- Fine-textured, white paper (any size)
- HB and 2B pencils, well sharpened
- Kneadable eraser
- Normal eraser

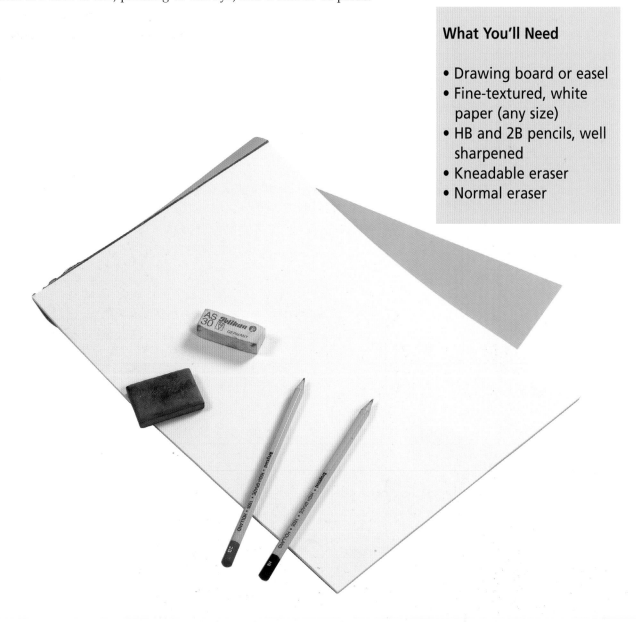

SEEING PERSPECTIVE

A few pages from now, we'll draw a still life that is made up of several objects with simple geometric shapes as an exercise in using perspective. Before we get there, however, we'll go over the basic points.

What is perspective? It's the collection of rules that allows us to give a drawing a feeling of space and depth. While the rules are important, they are mainly just a way to understand what we see. After all, we see perspective all the time—the trick is to realize what we're looking at.

The basic concepts in perspective are **horizon line**, **viewpoint**, and **vanishing point**.

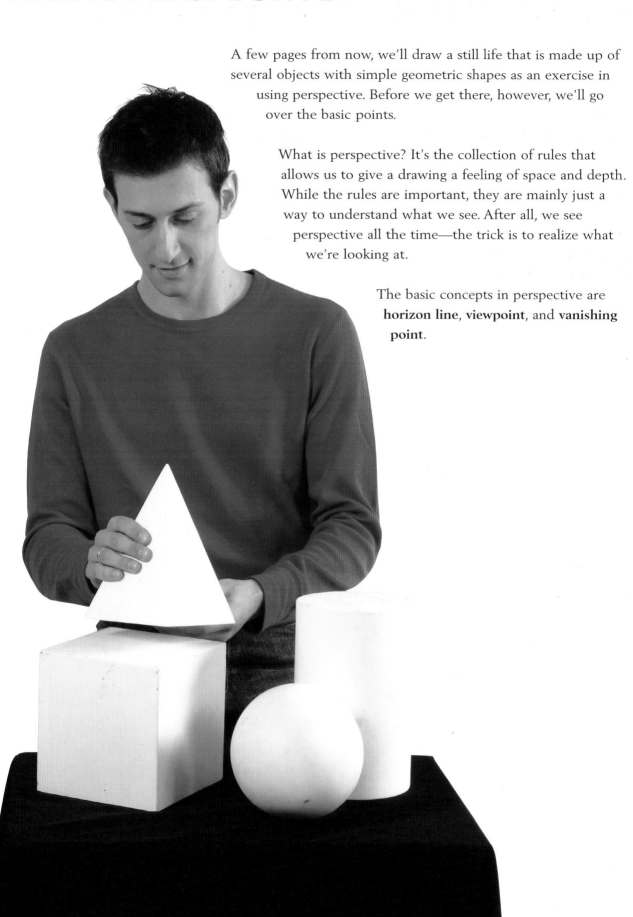

The **horizon line** refers to the actual horizon. Even though you can't always see it (if it's blocked by buildings, for example), it's always there. The horizon line is always at your eye level.

When you change your eye level, by sitting down, standing up, or climbing a hill, the horizon line also changes. We'll talk more about the horizon line later, when we talk about vanishing points.

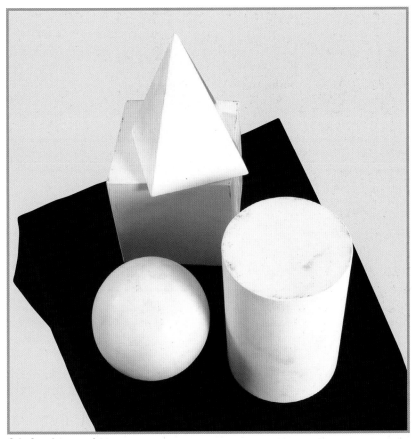

high viewpoint

Viewpoint is the combination of eye level and direction. In other words, your viewpoint, when you look at the subject you're going to draw, is made up of your eye level (for example, high or low) and the direction, or angle, from which you see the composition.

Your viewpoint is important because your drawing changes when your viewpoint changes. The more aware you are of your viewpoint, the more interesting and authentic your drawings will be.

Remember the cardboard frame that you used to view your composition (page 35)? When you move around and look through the frame, you're actually changing your viewpoint until you see a view that pleases you.

We'll talk more about viewpoint later.

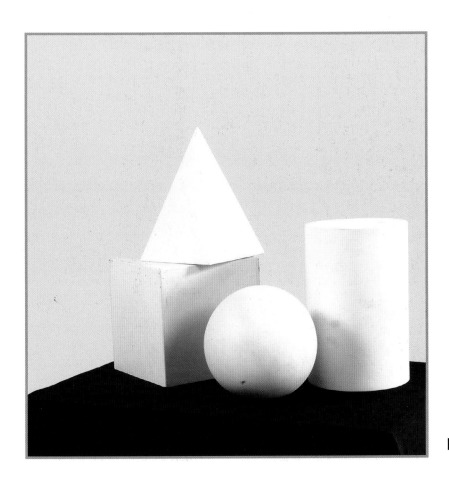

low viewpoint

All parallel lines that move away from you converge in a **vanishing point**. Vanishing points are always on the horizon line. The classic example of railroad tracks shows this in the clearest possible way.

Any drawing that contains shapes with straight lines, from books to buildings, has parallel lines that converge in a vanishing point, usually somewhere off your paper. In this chapter, you'll learn how to imagine these lines (or draw them, if it helps).

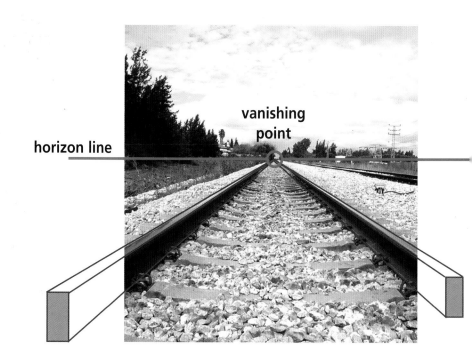

This picture has two sets of parallel lines, one for each side of the lighthouse that we see. Each set of parallel lines meets at a vanishing point on the horizon line far beyond the picture.

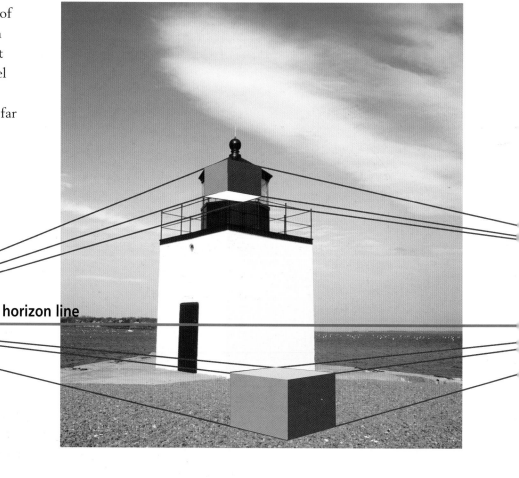

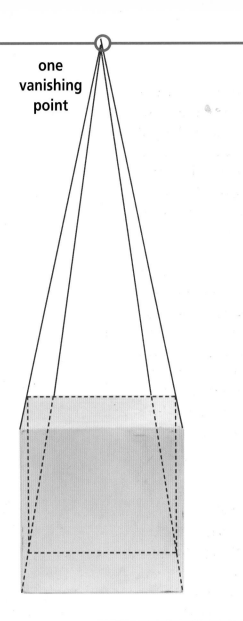

one vanishing point

The number of vanishing points depends on your viewpoint. Let's look at one of the basic shapes in drawing: a cube.

If you look at a cube from a frontal viewpoint, then there is only one vanishing point.

If you look at it from a corner viewpoint, then there are two vanishing points.

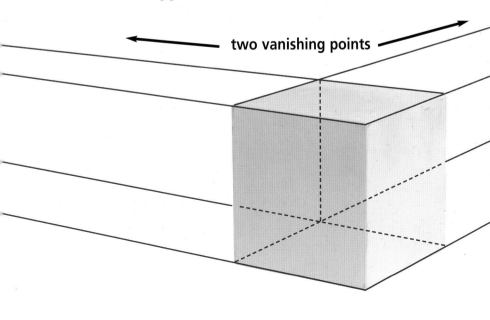

two vanishing points

All the *vertical* lines usually stay parallel to each other and don't converge in a vanishing point.

view from above

Now let's look at another basic shape in drawing: the cylinder. How a cylinder looks also depends on your viewpoint. Take a cylinder and follow along with me as we try a few simple motions. You'll see that the edges of the cylinder that you always thought of as round can appear elliptical or even straight.

When you look down at the cylinder from above it, your viewpoint is higher than the top, which looks round. If you raise the cylinder slowly toward your eyes, then your viewpoint is not as high as it was, and the circle narrows to an ellipse. The lower your viewpoint, the more narrow the ellipse. At eye level, the ellipse disappears completely and you see a straight line. Surprising, isn't it?

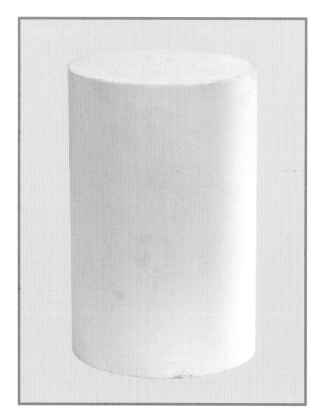

lower viewpoint

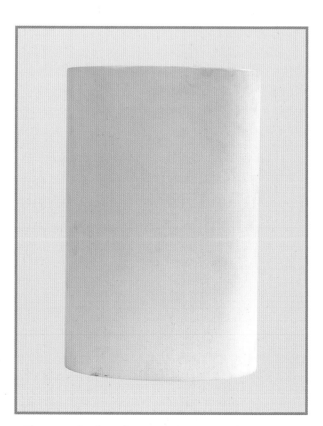

view at eye level

Here's a tip that will help you avoid a common mistake that I've seen over and over again in my classes: When you look at a cylinder from a high viewpoint (try this using a glass), then, of course, the bottom of the cylinder is farther from your eye level than the top. Therefore, the ellipse on the bottom is wider (rounder) than the ellipse on the top. That's why you should draw the ellipse on the bottom (the base of the object) as rounded.

My students often draw the base as a straight line, perhaps because they think that if the table surface is flat, then the base of the glass must be straight, too.

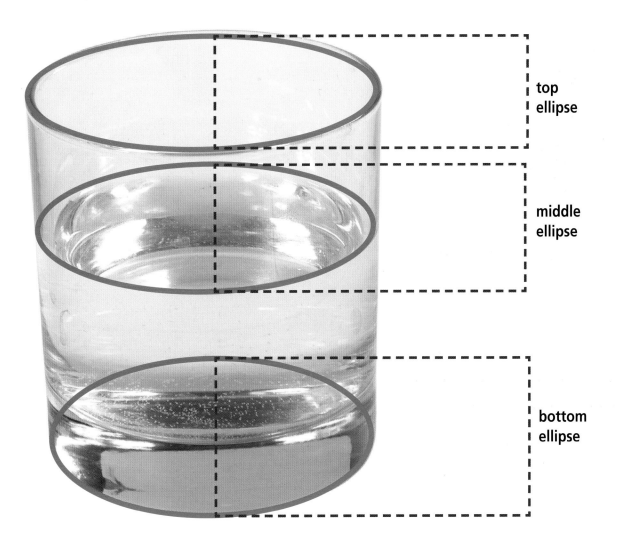

top
ellipse

middle
ellipse

bottom
ellipse

The rules of perspective are simply a matter of recreating optical effects in the way that you see them—once you realize how you see them. Take, for example, the three simple but important rules below:

1 Objects that are closer hide objects, or parts of objects, that are farther away.

2 If the closer objects are the same size as the farther ones, draw them a little larger. This will give a sense of the depth of space.

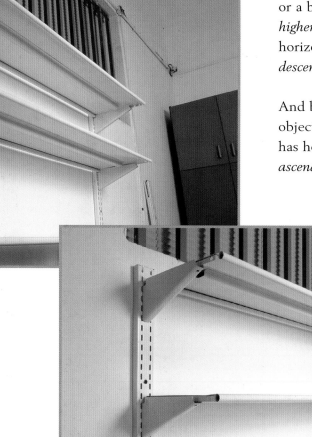

3 An object that contains straight lines, such as a shelf or a building, and that is *higher* than your eye level has horizontal elements that *descend* into the distance.

And by the same token, an object that is *lower* than you has horizontal elements that *ascend* into the distance.

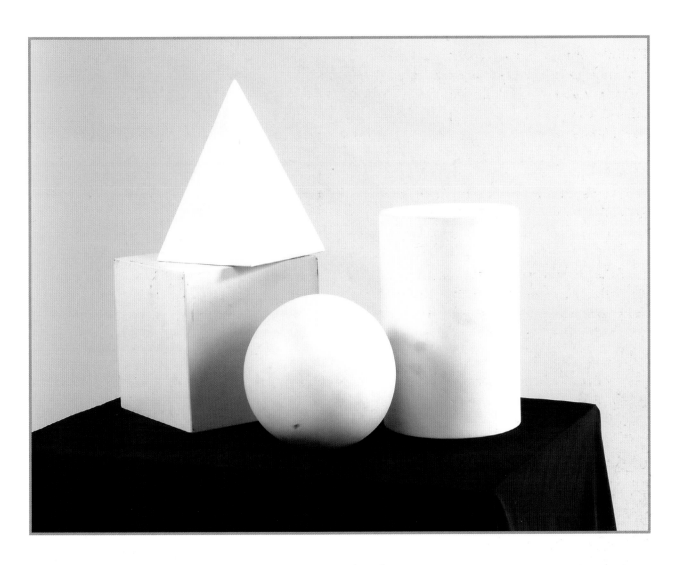

Now that you have the basic rules of perspective in hand, you can try them out by drawing a still life that is made up of several objects with simple geometric shapes.

I built this composition with a few items made of plaster that I use in class. Since you probably don't have plaster shapes lying around the house, you can use any objects that have very clear geometric shapes, such as books, boxes, cups, glasses, an egg, a ball, etc.

Remember to arrange your composition carefully, making sure that you have a little distance between the objects and that they slightly overlap each other. Check that your composition is not lit directly from the side or the front.

Look at your still life through the cardboard frame and find the view that you want to draw. For this exercise, make sure that your viewpoint is above the composition. (You'll find that this usually happens naturally.)

Just for Fun

Practice sketching things around your house using the rules of perspective. Try windows, shelves, and natural "still lifes" that occur on your desk or table. Don't read the cereal box—sketch it! (And the orange juice glass, too!)

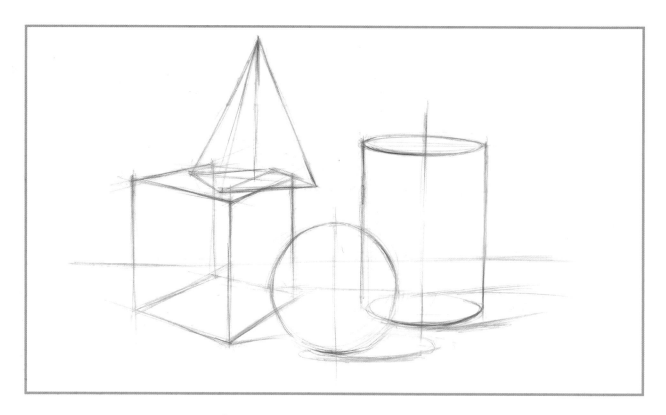

 As you did in Drawing 1 (page 37), use an HB pencil to draw the general outlines of the objects in your still life. Keep checking the proportions with your pencil and thumb. You can also draw the outlines of any shadows that fall on the table surface. Use the normal eraser to make any necessary corrections.

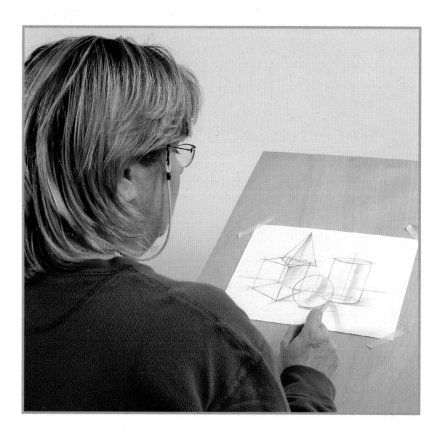

When you've drawn all the outlines, check that the composition you've got on your paper matches the one you chose in the cardboard frame. Go ahead, pick up the frame and look again.

This is a good time to make sure you've followed some basic rules of perspective that we talked about:
a. Objects that are closer hide objects, or parts of objects, that are farther away.
b. If the closer objects are the same size as the farther ones, draw them a little larger.

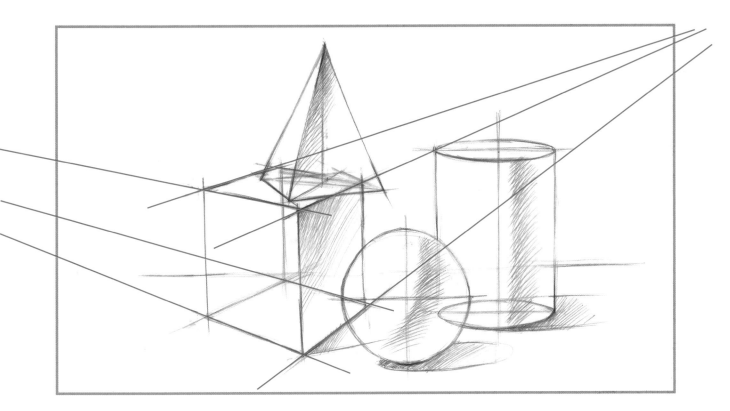

2 This is your chance to check and correct the perspective in the drawing. We'll look first at the shapes in the drawing that have straight lines: the cube and the pyramid. Even though, in reality, their horizontal lines are parallel, we see them as moving closer together as they extend into the distance, eventually converging in a vanishing point somewhere off the page (on the horizon line). As you draw, take this into consideration when adding "parallel" lines.

Because we see these objects from a corner perspective, we see two sets of "parallel" lines in both the cube and the base of the pyramid. If your viewpoint is frontal and you see only one side and the top of a cube-shaped object, then there is only one set of "parallel" lines that converge into a vanishing point. (See page 51 for a detailed illustration.)

The objects are lower than my eye level, so all their horizontal lines ascend as they get farther away. Try drawing the "parallel" lines in your drawing slightly beyond the borders of the object, which will help you see their direction better.

Because the distance between horizontal lines decreases as the lines get farther away, the vertical line that is nearest you appears to be longer than the more distant ones. Remember that all the vertical lines in the drawing are parallel to each other (both in reality and in your vision!).

In the cylindrical objects, check that the bottom ellipse is slightly wider than the top one.

Now that all the basic lines of the drawing are in place, you can begin to draw the shaded areas. Does your composition include any details, such as handles or decoration? You can start drawing those in, too.

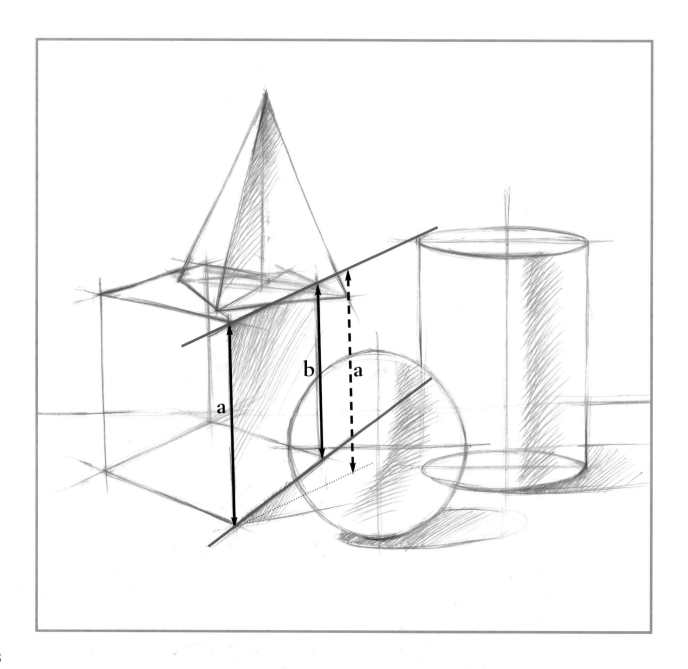

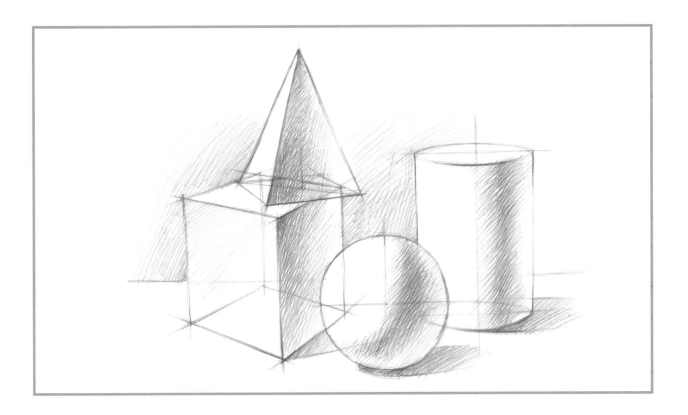

3 Now you can continue with developing light and shade. Look at your still life with your eyes squinted and draw in the shading of each object and the shadows that fall onto the table and other surfaces.

Remember to work on the entire picture as a whole, gradually developing the shading, without getting caught up in any one shaded area or detail.

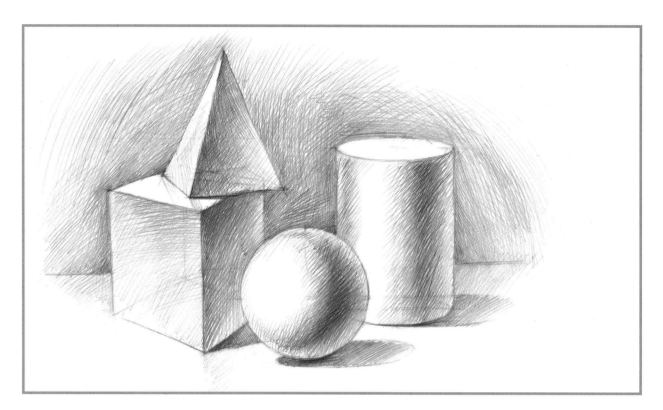

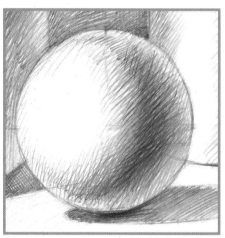

 Use the softer (2B) pencil to begin darkening the shading, using the kneadable eraser to lighten and make corrections.

Take a look at your composition carefully—specifically, at the shading on the objects. Is the shading uniform? No, it is not. It's darker or lighter in places because it's affected by light. The three tips below will help you see this effect and draw shading in a realistic way:

1 On objects with rounded surfaces, the shading is darkest toward the inside and lighter toward the edge. This effect is called "returning light," because light that is reflected from the surface of the table returns to the object and lightens its shade near the edge.

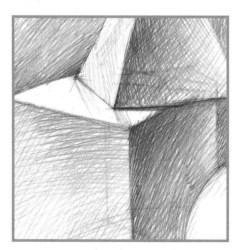

2 On objects with flat surfaces, if one side is receiving more light than the adjacent side, then the shading gets darker in the direction of the line that divides the two surfaces.

3 Sometimes the best way to show a lit surface is to leave it white and let the blank paper work by itself. This will strengthen the contrasts in your drawing. You don't always need to draw on every part of the paper.

With this drawing, we leave pencils behind as a main technique and move on to charcoal. You've done a lot of hard work in proportion and perspective. From now on, there are no more new rules. We'll concentrate on new techniques and materials, and you'll bring what you've learned to each new drawing. Good luck!

Key to Success

Redo Drawing 2 a few more times, choosing different compositions, until you feel more secure with the rules of perspec-tive and shading.

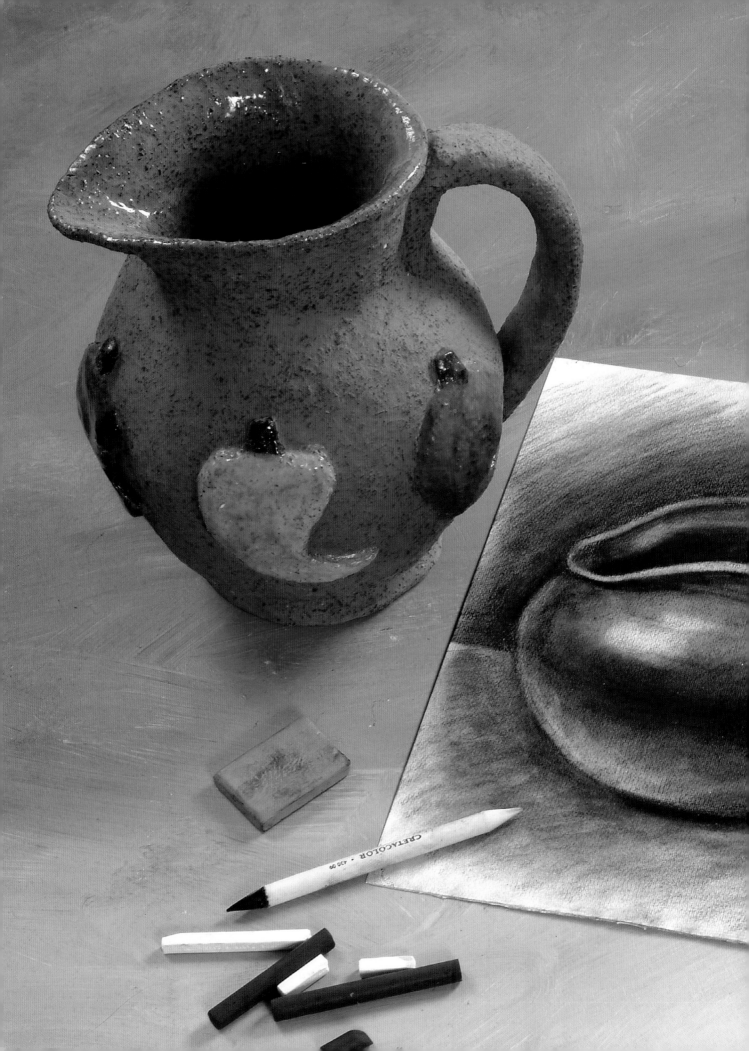

Charcoal

Now the work you've done in pencil, especially with light and shade, is really going to pay off. Charcoal is a wonderful medium for creating large areas of light and shade, and it offers a wide range of hues from light to dark.

Remember that all the rules of drawing you've learned so far also apply to charcoal and, in fact, to all other materials. Only the techniques change.

In this chapter, we'll work with two charcoal techniques: Basic Technique and Charcoal and White Chalk on Colored Paper.

Drawing 3: Basic Technique

I always plunge my students into this technique right after the pencil work and watch them revel in the material like children with finger paints. Don't be afraid to jump in and get your hands dirty—let yourself go!

For the drawing choose a single object: a pitcher with classic proportions, lit in a way that emphasizes its handsome shape and volume. Turn the object you choose until you find the lighting that best brings out its shape.

Remember to use your cardboard frame to plan the size and view of your still life on the drawing paper.

What You'll Need

- Drawing board or easel
- Medium-textured, white paper, at least 11" x 14"
- Synthetic compressed charcoal sticks
- Tortillon stump for blending (you can also use your hand)
- Kneadable eraser
- Soft cloth
- Fixative

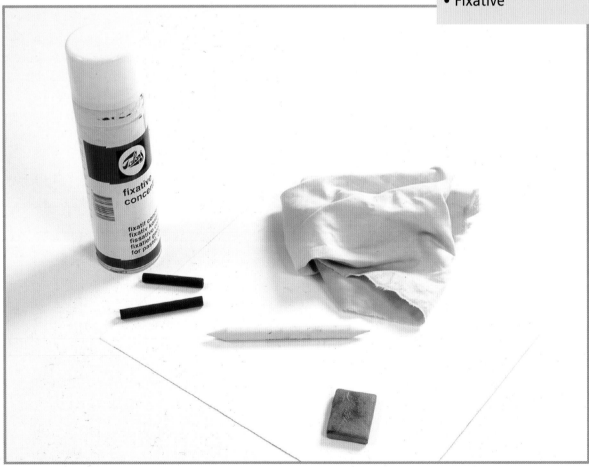

 Start by preparing the paper: with the side of the charcoal stick, darken the entire surface of the paper. Then blend the charcoal with the tortillon stump, a soft cloth, or the palm of your hand. The tone should be a medium gray (not too black, not too light).

This tone will serve as the medium tone of your drawing. Later, you will lighten the lit areas and darken the shaded areas.

In this technique, you'll draw the object entirely through areas of light and shade, using the charcoal and the eraser, without drawing an outline first. As you go, you can correct the shape by making changes in the shading.

Darken the large shaded areas with the end of the charcoal, to indicate both the object's shading and the shadows on the table surface.

As you use the charcoal stick, the end will take on the shape of a cone that comes to a point. You can use the broad side of the cone for large areas and the point for detail work. As you go, use the stump or your hand to blend the charcoal.

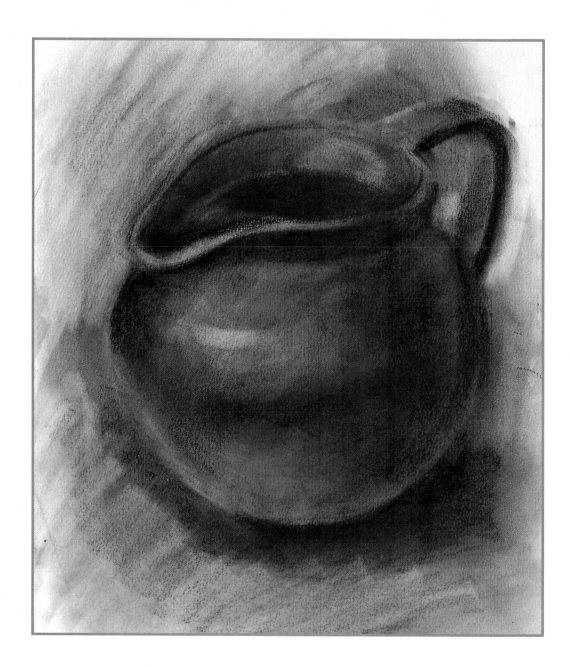

shading with charcoal

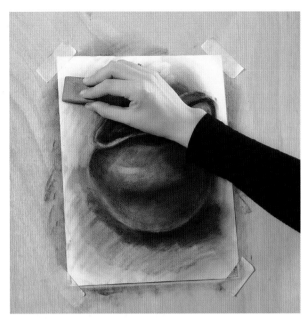

shading with eraser

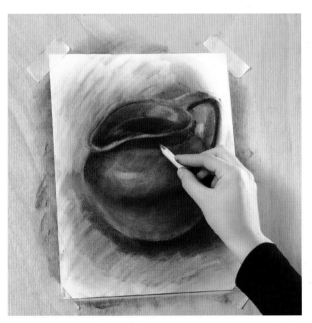

blending with stump

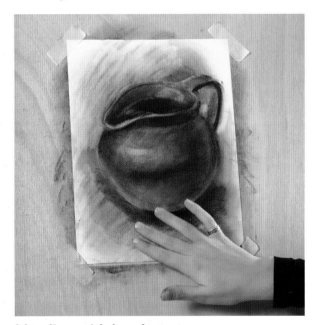

blending with hand

At the same time, use the eraser as a drawing tool for lightening the lit parts of the object.

Remember that the background is an important part of your drawing. If you want the shading near the edge of the object to be darker than the background, you can either darken the shading with the charcoal or lighten the background with the eraser. You'll achieve the same effect either way.

In this technique, you're always going back and forth between the charcoal and the eraser. And as always, you're working on the whole paper at the same time—the object, the background, and the table surface.

You now have the initial relationships between light and shade, and the object has begun to look three-dimensional and to "come off" the paper.

Key to Success

Here's a tip that will help you see when your symmetrical objects are out of shape, or when objects in your drawing are tilting to one side: hold your drawing up to a mirror! Mistakes that you couldn't see when you looked directly at your drawing will suddenly jump out at you.

3 Continue using both the charcoal and the eraser: correct the proportions of the object more precisely by darkening with the charcoal or lightening with the eraser.

Draw in the details that you need. For example, you can see that the opening of the pitcher was finished with a line of light that gives the ceramic its thickness, and that the shade was darkened clearly in the handle.

Have you created strong contrasts and clear relationships between light and shade? Take another look at the drawing for Step 2 (page 66). It's mostly made up of grades of gray, with no sharp black or white contrasts. Does your drawing still look like that?

If so, take a step back from it and see where you need to sharpen the contrasts. Blacken the darkest places completely, and make the lightest places as light as you can with the eraser.

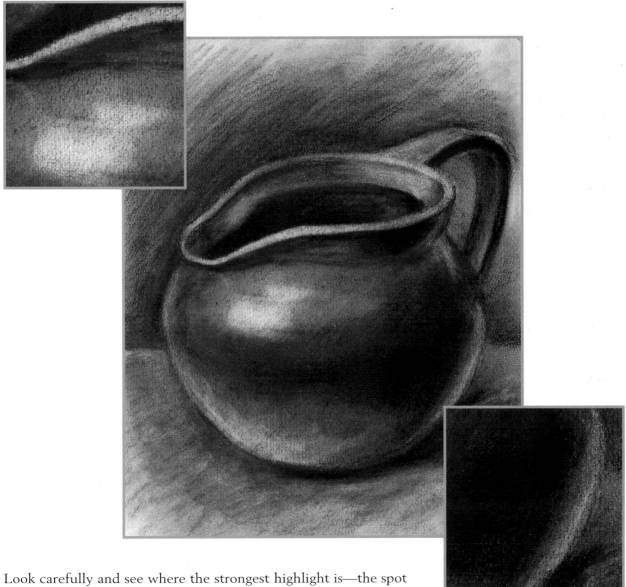

Look carefully and see where the strongest highlight is—the spot where the light creates a bright patch that seems to be lit with a spotlight. In almost every object that is receiving light, there is either a spot or a line that is brighter than any other. That's the place where the object is receiving direct light at a 90-degree angle. Use the eraser here to achieve a white spot.

You can clearly see in the drawing where the returning light from the table lightens the edge of the pitcher. Lighten the returning light on your object, too.

This is the last step, so when you're ready, spray your drawing with fixative.

Our next drawing continues with charcoal and adds the accents of white chalk and colored paper.

Drawing 4:
Charcoal and White Chalk on Colored Paper

My students love this technique, because it's relatively easy to achieve truly striking results. The white chalk gives you much more latitude in developing light and shade than the previous technique, and the color of the paper offers added richness. The color should not be too bright, however. Try a gray-based blue or green paper, or a brown hue, and choose a size and shape that fit the proportions of your composition.

What You'll Need

- Drawing board or easel
- Medium-textured, colored paper (any size)
- Synthetic compressed or natural charcoal sticks
- White chalk sticks
- Tortillon stump
- Kneadable eraser
- Fixative

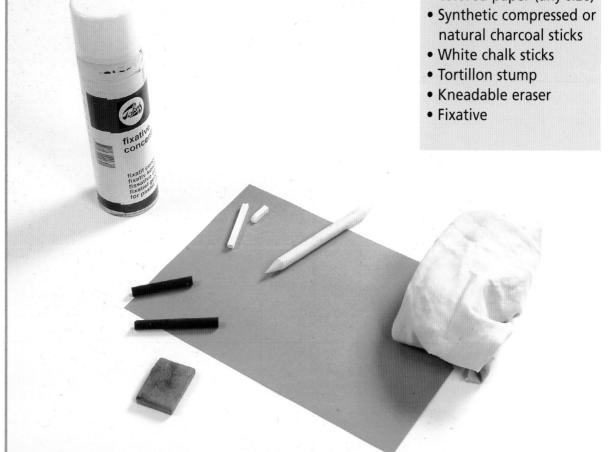

For this drawing lesson I've chosen a photograph of buildings in Prague. I find that I return to scenes from this beautiful city again and again for archi-tectural subjects. You can join me and draw the view in a photograph, perhaps from a favorite trip, or even a view from your window.

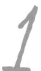

This time, the color of the paper will serve as the middle hue, so there is no need to cover the paper with charcoal first.

Start by studying your subject and determining what your viewpoint is. Are you looking up or down at the buildings? Keep in mind here what we said in our discussion of the rules of perspective (page 54) about the direction of horizontal lines: in the elements that are higher than you (above the horizon line), the lines descend as they get farther away, and in those that are lower than you (below the horizon line), the lines ascend.

Look at the horizontal lines in the drawing. The lines near the roof and below the windows (which we are looking up at) descend as they get farther away, and the horizontal lines on the sidewalk (which we are looking down at) ascend.

Using the charcoal, draw the general shapes of the buildings and other objects with confident, free lines. In this technique, you don't need to dwell on edges and other details. Look at how the windows are drawn, for example, with just a few lines.

Draw in shading using the side of the cone of the charcoal stick. You can blend some of the lines and dark areas with the tortillon stump or your fingers.

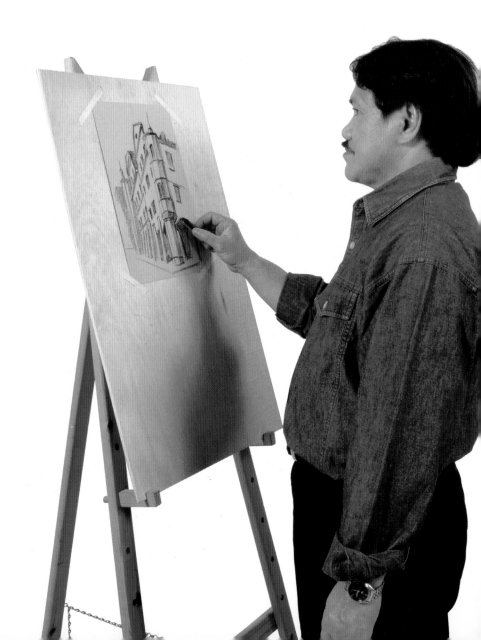

Continue working on light and shade, beginning with the elements that are closer and more important. Give them sharp contrasts, using the white chalk to emphasize the lit areas. Remember that the color of your paper is the medium tone between the charcoal and the white chalk.

Look carefully at the differences in tone among the areas of shade; make the darker ones darker and the lighter ones lighter. You can lighten shaded areas using the kneadable eraser.

Notice how almost all the shading work in the closest part of the drawing has been done. The more distant elements remain in shades of gray. That's also the way we perceive scenes with our eyes: details that are closer to us stand out more and have more contrast, and those that are farther away tend to blend into shades of gray.

Make any corrections that you need using the kneadable eraser, the charcoal, or the white chalk.

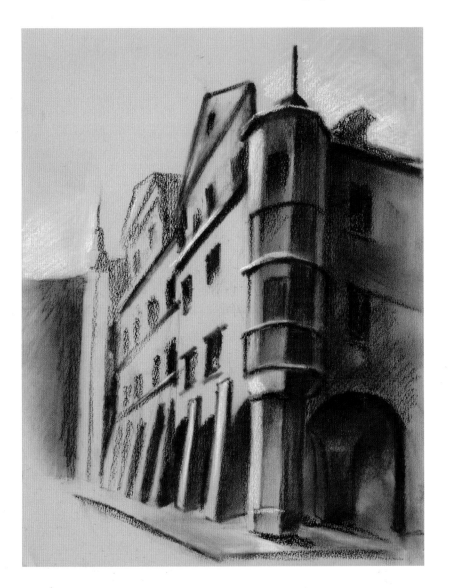

Key to Success

Here's a tip that will allow you to draw more easily and freely: use one end of the tortillon stump for blending charcoal and the other for blending the white chalk. If you're using your fingers, you can do the same thing—use one finger for charcoal and another for white chalk.

3

Go ahead and devote some time to the details. In this drawing, the windows, the design elements on the building, and the structures in the distance have been added.

This is also the time to make the areas of light and shade that you drew earlier more defined. You can see how this has been done in the drawing.

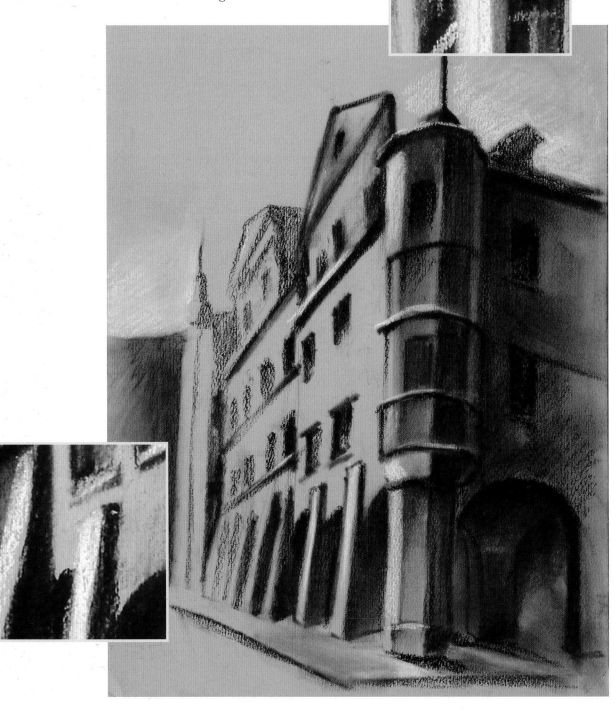

Take another look at the distant buildings in the drawing. As you can see, even though the shading is sharpened, these buildings are purposely left undefined.

There's a lot to think about in an architectural drawing like this, I know. Don't try to accomplish everything the first time. As in all of our drawings, if you enjoyed the technique, then try it again!

(Don't forget to add the fixative.)

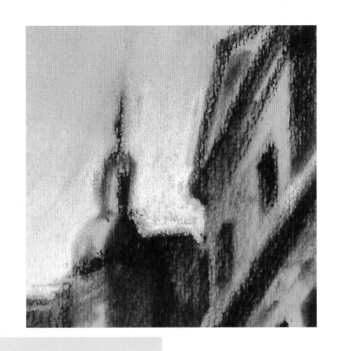

Just for Fun

Charcoal technique is very similar to sanguine technique, which we'll use in the next chapter. Why not get a head start? Try the charcoal drawings again, only this time, use sanguine or sepia instead of charcoal.

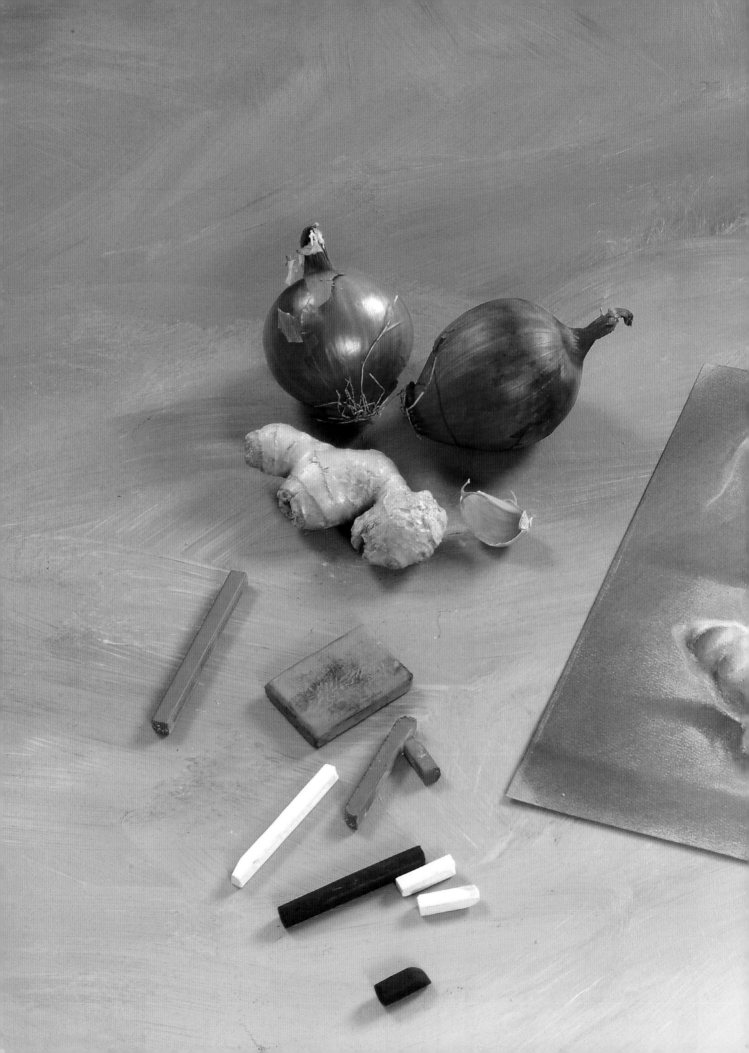

Sanguine/Sepia

Known for their blood-red color, sanguine crayons have been a favorite of artists for centuries and appear in many drawings by the Old Masters, including Rembrandt and Rubens. We'll use sanguine in a classic combination with charcoal and white chalk, but you may find that you enjoy using it in different ways that you discover on your own.

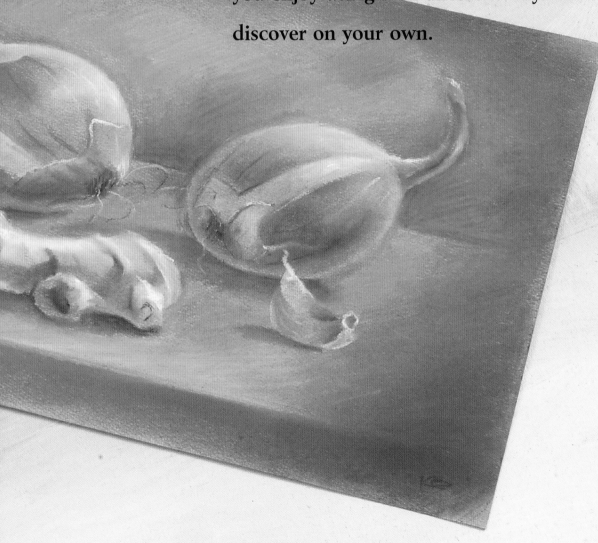

Drawing 5:
Three-Pencil Technique

Sanguine can produce delicate gradations of shading, and it's lighter and more luminous than charcoal. That's why the two contrast with each other so beautifully, as you're about to see.

In the Three-Pencil Technique, known in the art world as "Trois Crayons," we'll work with three materials: sanguine, charcoal, and white chalk. The sanguine will provide the middle tones of the drawing, charcoal the darkest shading, and white chalk the highlights. If you want, you can substitute sepia for the sanguine; it has a similar earth tone.

For this drawing, I chose a still life with two onions and a ginger root. You can also choose three to five simple objects with clear shapes that you have at home. I recommend a light brown paper; mine is a light ocher color.

What You'll Need

- Drawing board or easel
- Medium-textured, colored paper (any size)
- Sanguine (or sepia)
- Charcoal
- White chalk
- Tortillon stump
- Kneadable eraser
- Fixative

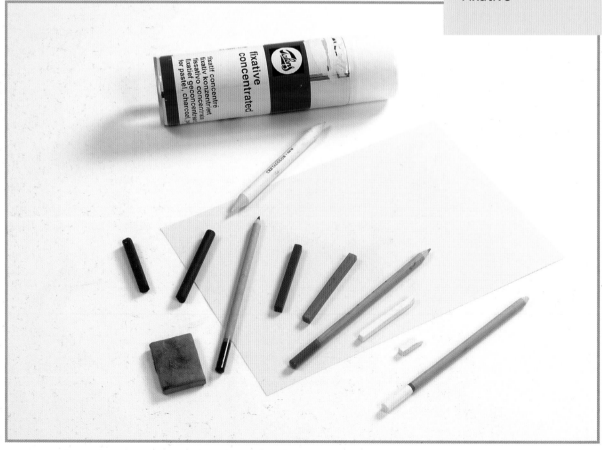

Begin with the sanguine and, as always, start out by working on the main shapes. Draw the outlines of the objects in your composition.

Check the proportions and the perspective carefully. The composition has only round or irregular objects, so you don't have many issues of perspective to deal with. If you have straight lines or cylinders, though, then you'll need to be more careful.

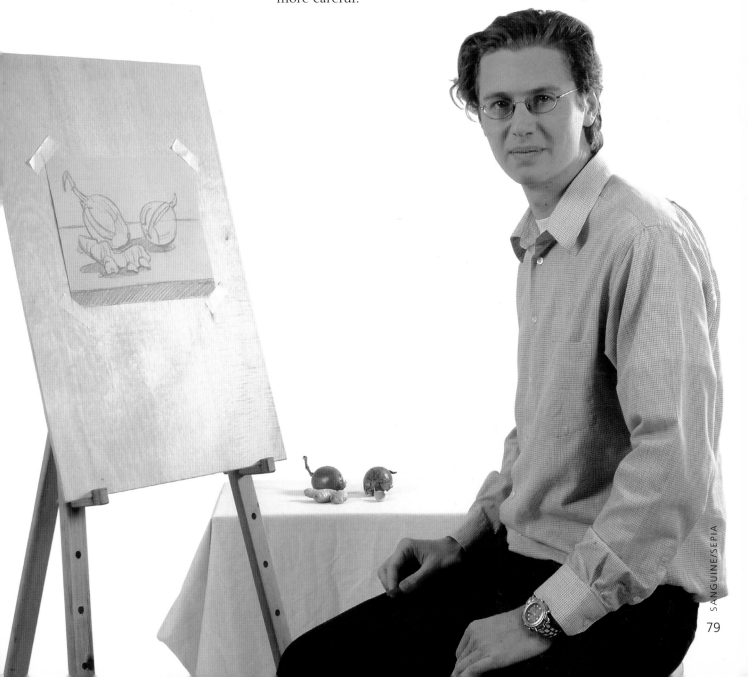

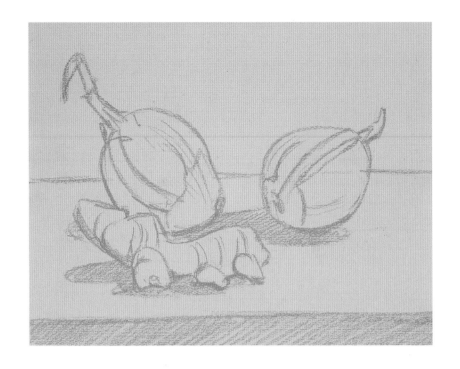

Darken the shadows on the table surface with the side of the sanguine, as in the drawing.

By the way, you can see that, for the first time, the edge of the table is included as part of my composition. This was done simply to provide a contrast of the horizontal lines with the rounded shapes and make the picture more interesting.

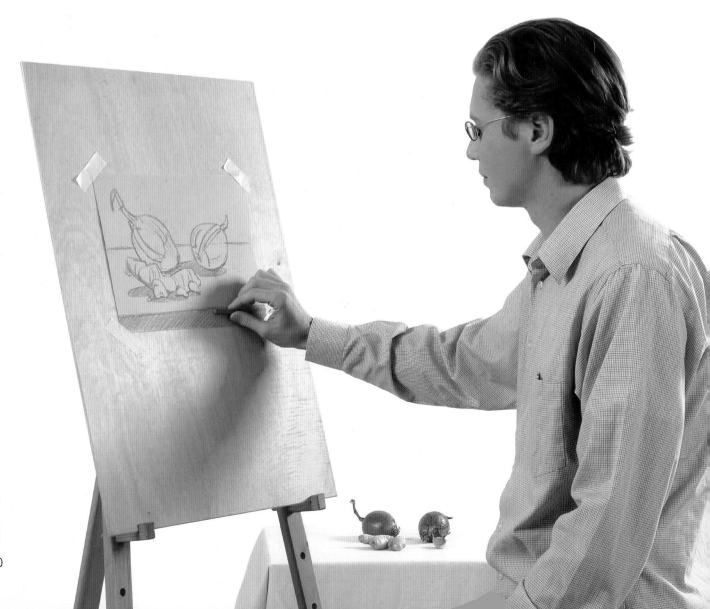

 Check your subject again and study the relationships between light and shade.

Still using the sanguine, draw in the shading and then blend with the stump or your finger. This brings out the volume of the objects. To get lighter tones, try drawing with the leftover sanguine on the stump or your finger. That's how the light areas of shading on the onion was drawn.

Always work on the entire paper, comparing the different parts of the composition. Notice where the shading is lighter and where it is very dark.

You can see that work has begun on the background of the drawing. In this step, it's important to see and understand the relationship between the objects in your composition and the background.

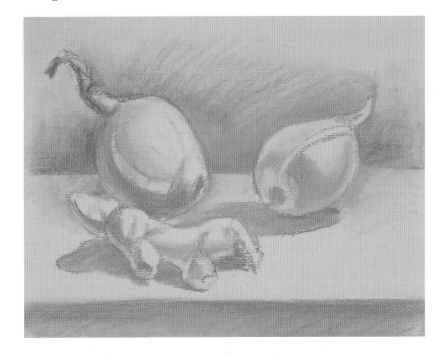

Although you've only used the sanguine so far, your drawing is becoming more finished as its shapes are brought out with shading.

Keep comparing your drawing to the subject, and don't forget to back away from your work and look at it from a distance.

$\mathcal{3}$ Now it's time to bring in the charcoal and the white chalk. Use the charcoal to deepen the shading and make stronger contrasts where you need them. This will further define the shape and volume of the objects. Work delicately and carefully, so that the charcoal doesn't stand out too much in the drawing.

In lit places, work with the white chalk. Don't get carried away—light tones should be strengthened gradually just as dark tones are. Always remember that it's easier to add than to erase. It's very important to preserve the wholeness of the drawing and not to let it disintegrate into separate areas of color or light.

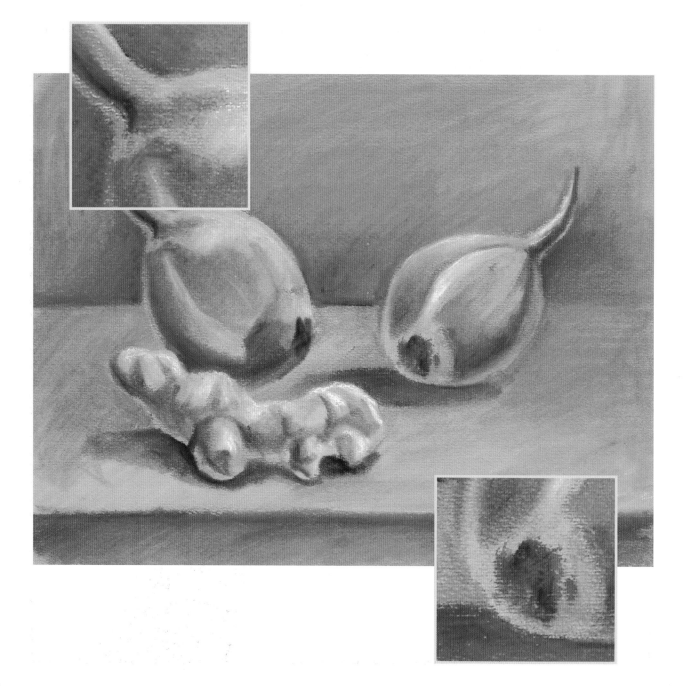

You can also blend charcoal or white chalk with a stump or your finger, just as you did the sanguine, to create gentle transitions from tone to tone.

What you don't want to do is to blend the charcoal and white chalk together. This will create an unwelcome gray tone. Keep the ends of the stump separate—one side for charcoal and the other for white chalk. If you're using your fingers, keep them separate, too.

 You've reached the final step in the drawing. Be sure to take a moment to look again at both the subject and your picture with your eyes squinted. Make any corrections and changes using the different techniques you've learned so far, including drawing over and lightening.

Take the white chalk and draw in the highlights (the lightest spots in the drawing). Work on the details to finish the fine points. If necessary, soften places that are standing out too much with the kneadable eraser.

Make sure that the details you've drawn don't divert attention from the main shapes. If they do, just smudge lightly with your finger or dab with the eraser to lighten and blend.

Just for Fun

If you liked the Three-Pencil Technique, you'll love this combination: sanguine, sepia, and white chalk. Use colored paper and follow the same steps, replacing the charcoal with the sepia. Give it a try!

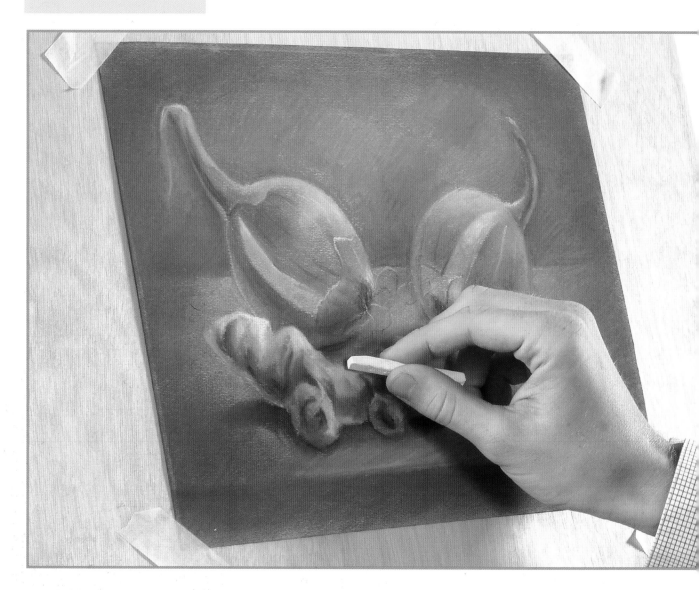

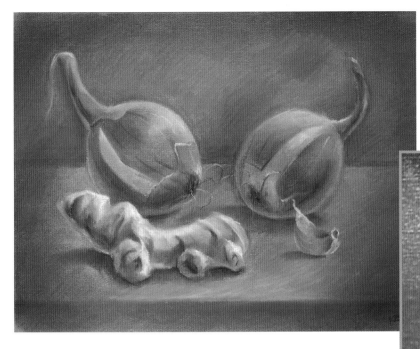

Go over the major elements one last, but very important, time. In this phase, the contrasts around the periphery of the entire drawing were blended in and de-emphasized. You can see that the edges of the table are not clear; this focuses attention on the composition.

Finally, spray your drawing with fixative.

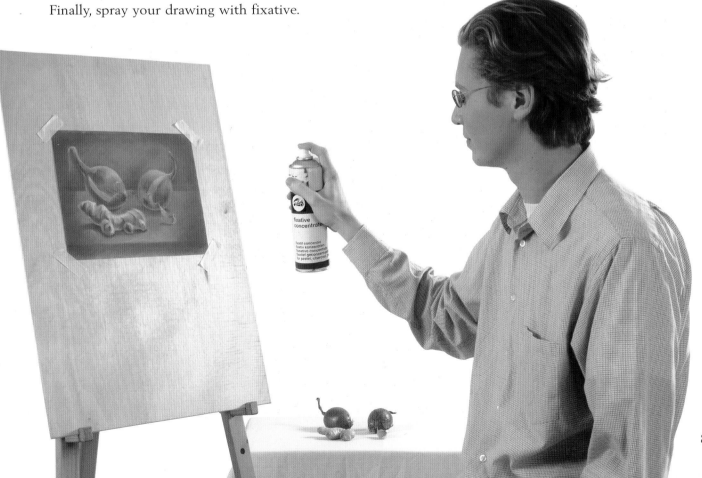

Ink

When drawing with ink, we'll use the brush as a drawing tool. Compared with materials we've used until now, such as pencils and sticks, brushes can offer a freer, more flexible style and a wider range of possibilities. Think of Chinese calligraphy, where drawing letters with ink and brushes produces such beautiful, artistic effects. Drawing with ink and brushes is actually very close to painting, especially to water-color technique.

Drawing 6:
Ink with Soft Brushes

This technique, unlike the Dry Brush Technique, uses ink mixed with water to achieve gradations of shading.

We'll use black ink for this exercise, either dry or liquid. Dry ink demands more work on your part, but some artists prefer it precisely because of that hands-on feeling. Think of it as the difference between standard shift and automatic cars: if you prefer automatic, then choose the liquid ink, which you can use right out of the jar.

For this lesson, I've chosen another urban view of Prague. You, too, can draw a photo (or an actual view) of a city scene, as before.

What You'll Need

- Drawing board or easel
- Rough-textured, white paper (any size)
- Scrap paper for testing
- Black liquid ink, or dry ink with ink stone
- Soft, round brushes (watercolor brushes), #4 and #8
- HB pencil, well sharpened
- Soft cloth
- Normal eraser
- Masking tape
- Watercolor palette, ceramic tile, or plate
- Sharp knife
- Container for water
- Container for ink (optional)

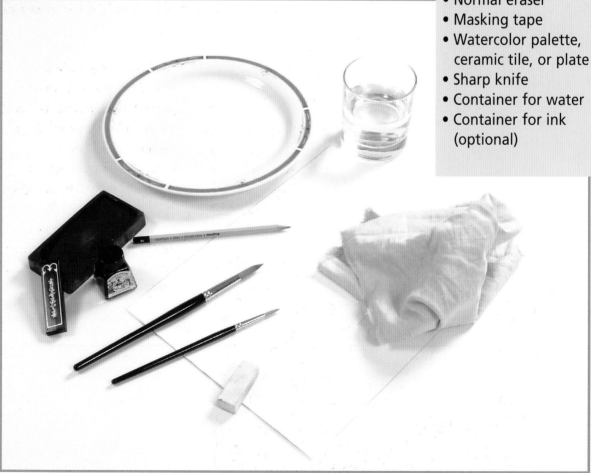

Attach your paper carefully to a drawing board (or easel) with tape around the entire paper. Make sure that the textured side is facing up.

Don't be afraid to work, as always, with your paper tilted at an angle to avoid distortion.

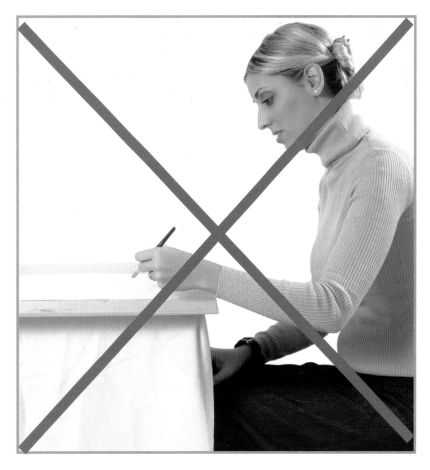

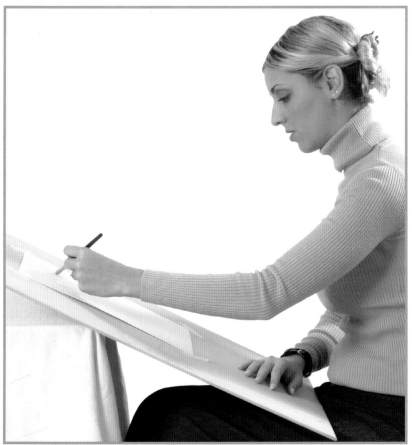

My beginning students usually try to keep their paper flat on a table or their knees to keep the ink from running. This is not necessary, and in fact, the surface must be at an angle so that the ink can flow down the paper and not gather into puddles on your drawing. Let's get started and you'll see what I mean!

Use your HB pencil to draw the general outlines of your composition with narrow lines.

Try to work as accurately as possible, because too much erasing can destroy the textured surface and make it harder for the ink to adhere to the paper.

Perspective is very important here, as in all architectural subjects. Because we're dealing with straight lines and distances, try to keep the rules of perspective in mind as you work. Don't hesitate to refer back to Drawing 2 (page 46) to go over the basic rules again.

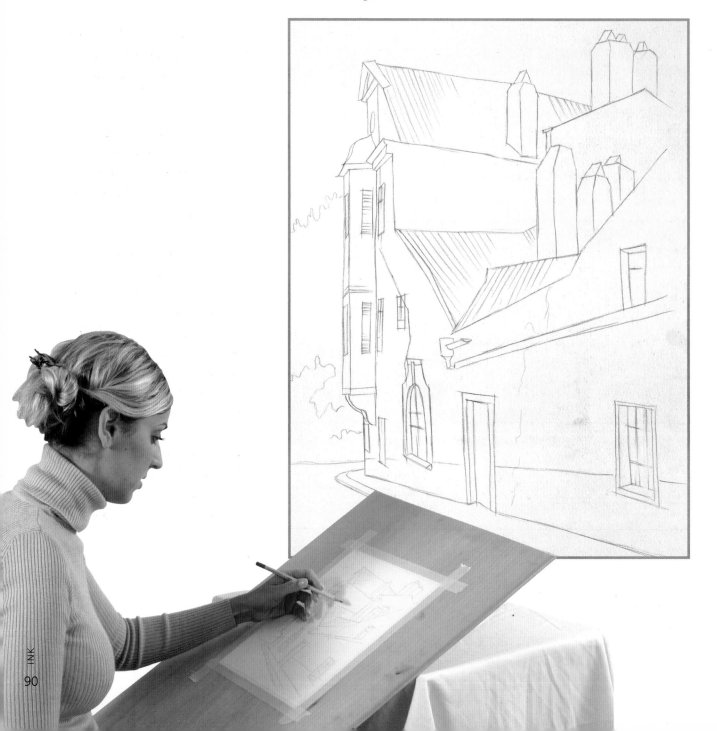

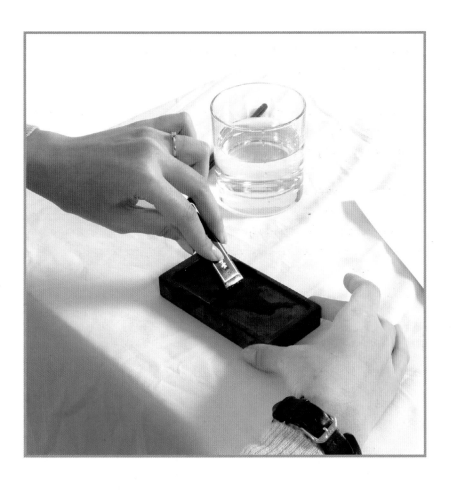

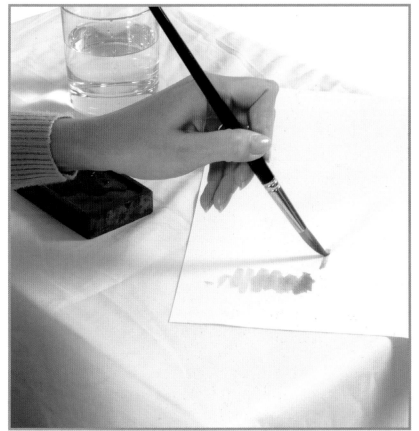

2

Now you can prepare your ink solution. You'll need about $1/2$ cup of diluted ink. The solution should be a light gray that is still clearly gray. When you're new at it, you may tend to make the solution too transparent, so be sure to add enough ink.

If you're using liquid ink, just take a few drops of the ink from the jar and mix them with water in a glass.

To see how to make ink solutions from a block of dry ink, you can check the "Tools of the Trade" chapter (page 26).

Basically there are two ways to mix dry ink:
a. mix it with water right in the ink stone, or
b. scrape some of the black ink powder into the ink stone and then pour it into a glass, where you can gradually add water.

In all cases, keep checking the solution with your brush on a separate piece of paper until it is the right shade of gray.

3

Take the larger (#8) brush and cover all the shaded areas with ink. Work with quick, confident, horizontal strokes from the top of each area to the bottom. Keep your brush wet with ink as you work. At the same time, keep gathering up the drops of ink that collect at the bottom of each darkened area by drying the brush with a soft cloth and dabbing off the drops.

You can see in the drawing that, as the ink runs, it smooths out the horizontal lines and creates solid-colored shaded areas.

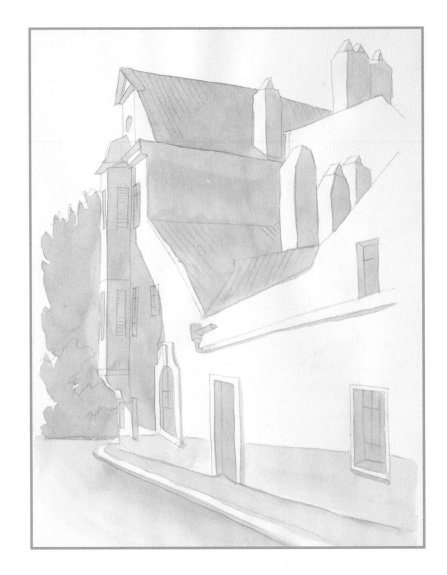

Each layer of ink needs to dry. It's not a good idea to work on the drawing when it's only partially dry, because each succeeding layer will smear the earlier ones. You can work on a freshly wet area, but once you leave it, you'll have to wait until it's dry to go back to it. This demands some patience on your part, but the results are worth it!

4

When the first layer of the drawing has
dried (usually after three or four minutes),
you can continue on to the darker second
layer. Using the same ink solution as
before, strengthen the darker places within
the shaded areas.

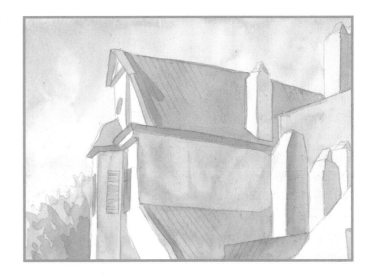

To achieve a gradational effect from the
dark tones to the light, start on a darker
section with the ink at its strongest con-
centration, then dip your brush into clean water and draw a
lighter section of the shading; dip your brush into water again;
draw an even lighter section, and so on. Don't be afraid to keep
the lit places white. You can see this effect on the street in the
drawing.

If the second layer is still not dark enough in some places, you
can add a third and fourth layer.

5

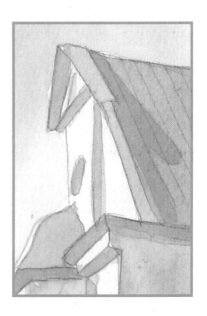

Use the smaller (#4) brush to add more contrast to the drawing
by blackening the darkest places. If you're using dry ink, make a
small amount of a black solution in the ink stone. If you're using
liquid ink, you can use it straight from the bottle.

As you can see in the drawing, some of the darkest areas are
black, but others are actually dark shades of gray. You can get the
hue you want for each darkly shaded area by mixing the ink
with water on a palette or tile. Just put a small amount of ink on
the palette and then add water to lighten it. If it's too light, add
more ink. When the tone is right for one area, draw in the
shading and then mix a new tone for the next area that you
want to darken.

While you work, remember to keep gathering up the leftover
drops of ink with a dry brush.

As before, if you want to achieve gradations of shading, keep
dipping your brush into clean water.

When you're ready, draw in the fine details. If you need white detail on an area that is colored with ink, you can scrape the ink off with the point of a sharp knife. That's how the white lines on the first-floor windows in the drawing were "drawn" in.

When the drawing is dry, carefully take off the masking tape. You'll see that removing the tape leaves an attractive white frame around the drawing.

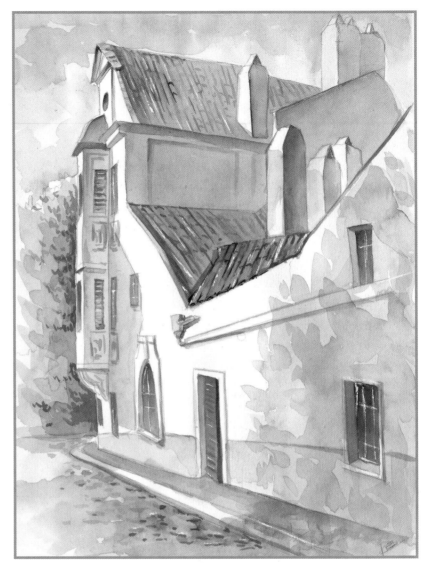

Just for Fun

Try this technique using ink or watercolor in a quiet color, such as deep blue. You can also try a light-colored paper for a different effect.

Drawing 7:
Dry Brush Technique

Unlike the Ink with Soft Brushes Technique, which calls for some patience, the Dry Brush Technique is more suited to quick, expressive sketches. That's why I didn't separate this exercise into steps. The idea here is to let yourself go, be brave, and just do it!

For this lesson, I've chosen to draw an architectural study of (you guessed it!) Prague. You're welcome to choose a similar subject, although it's certainly not a must. The important thing is to choose a subject that doesn't have a lot of fine detail.

What You'll Need

- Drawing board or easel
- Medium-textured, white paper (any size)
- Scrap paper for dripping
- Black liquid ink
- Hard, flat brush, #5
- Metal or reed quill pen

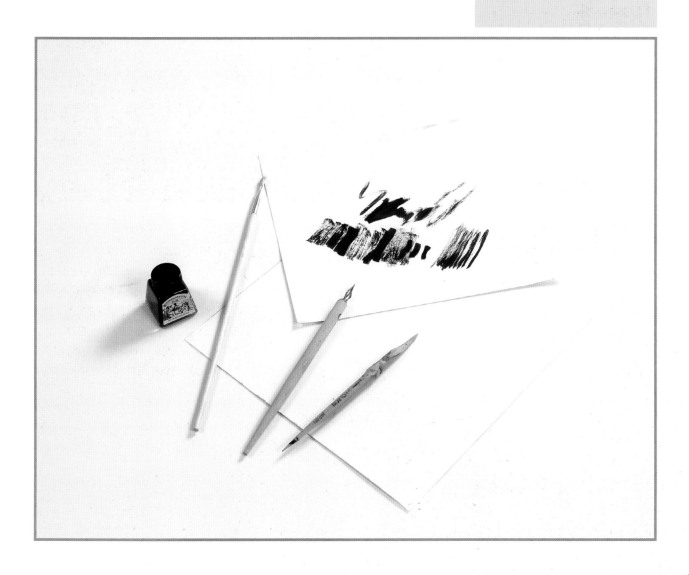

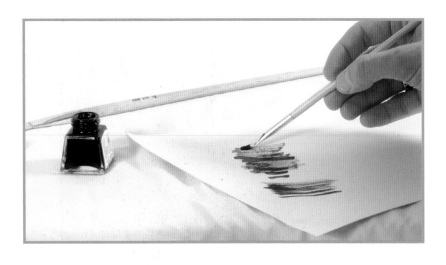

Dip your brush into the ink and let the excess drip onto a piece of scrap paper.

While the ink on the brush is still very black, draw in a few of the most important lines in your composition. These will help you keep your place as you continue to draw. This drawing was started with the lines of the bridge and some of the main outlines of the buildings.

At this point, what you've learned about working on the whole drawing at one time will serve you well. Quickly use the rest of the ink on your brush; because the ink is getting used up and lightening as you go, you'll get a lighter shade of gray with each stroke.

Move confidently around your picture, drawing in dark, medium, and light shading. When the ink on the brush is almost gone, draw in the lightest areas. You can see where this was done in the background and in some of the shading on the buildings. Remember that you can use the white of the paper itself for the very lightest areas.

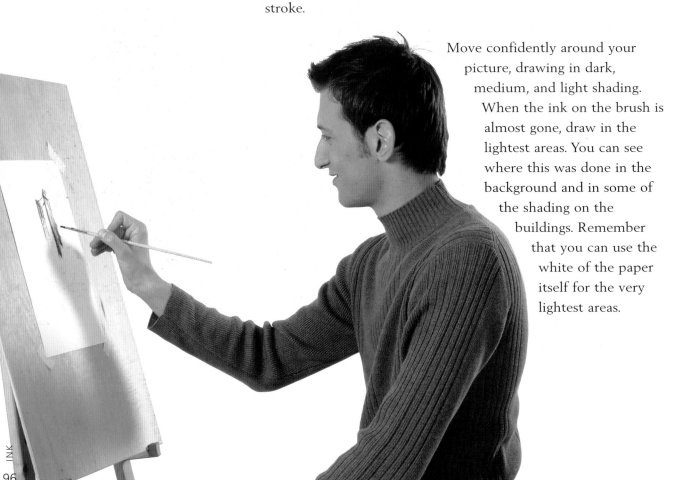

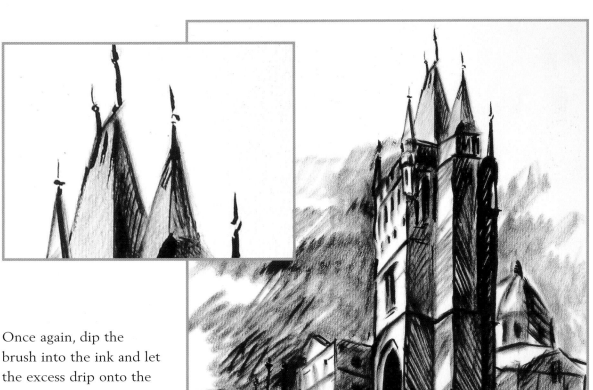

Once again, dip the brush into the ink and let the excess drip onto the scrap paper. While the ink is dark, draw in the darkest areas in the drawing with free strokes. As the ink on the brush runs out, continue on to the lighter places in the drawing, as before.

Keep repeating the process: dip the brush, drip off the excess ink, and draw dark, medium, and light areas of shading. In this technique, it's very important to see the general contrasts and relationships between light and shade and not to get bogged down with small details.

You'll see that, with practically no ink left on the brush, you can make very subtle, nearly transparent grays. These are not only useful for shading partially lit areas, but give your drawing more softness than you might expect in a black and white medium.

At the end, when you're finished working with the brush, you can draw in the finest details using a metal or reed quill pen. You can see where this was done at the top of the spires.

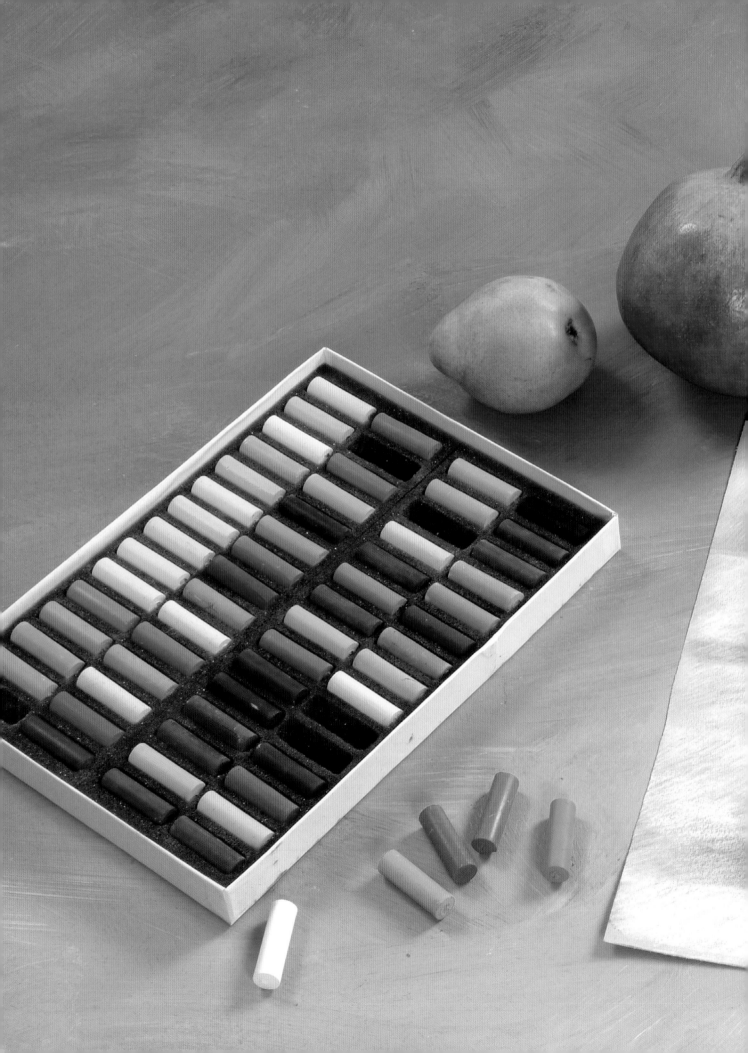

Pastels

You've tried out a range of techniques, and now you're ready for a giant step forward— into the world of color. Pastels will astonish you with their wide array of bright colors. You already know a lot about using them, because they're very similar to charcoal, sanguine, and chalk.

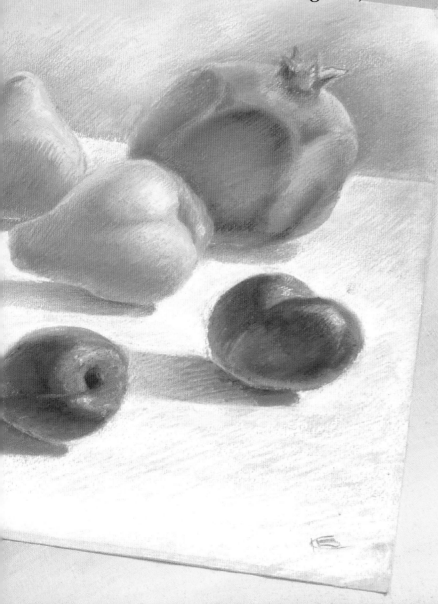

Drawing 8: Still Life

Pastels glide onto paper easily and adhere well, creating especially pleasing effects on textured paper. They blend beautifully, so the range of colors you can achieve is limited only by your imagination.

For this drawing, I will use a composition of several pieces of fruit and work on light blue-gray paper. You could put together a composition like mine, or perhaps choose a vase of flowers. Stay away from complicated subjects for now, because this is the first time you'll be working with color. Try something that will allow you the freedom to play with colors and tones.

What You'll Need

- Drawing board or easel
- Medium-textured paper (white or any color, any size)
- Set of soft pastels
- Soft cloth
- Kneadable eraser
- Fixative

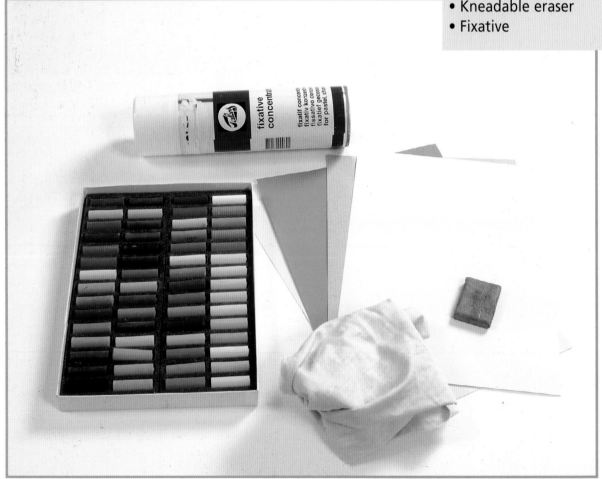

**1**

Using a grayish pastel, draw in the outlines of the drawing. Pay special attention to the proportions and the perspective—at this stage, these are more important than the color.

Don't worry about mistakes or extra lines. Although you can lighten them slightly using the kneadable eraser, they will all be covered up with color as you work on the drawing.

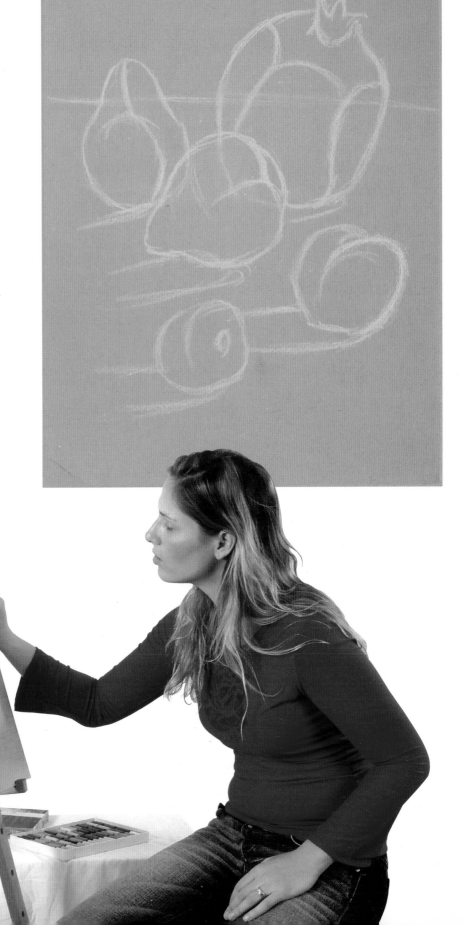

2

Now you'll move on to shading, and this is where the color comes in!

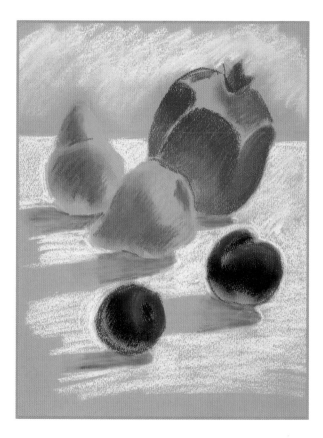

It's up to you, of course, what colors you choose and how realistic you want to be. Keep in mind, though, that just as your work in shading trains you to see objects in a new way, using color does, too. You'll start to realize that the colors of an object, especially as affected by light and shade, are much more varied than you had thought.

Don't get carried away with mixing colors at first. Try to use the pastels as they are, depending on the size of the set you have: if you have a large set, then you'll find the colors you need; if you have a very small set, you may need to blend colors sooner in order to achieve the colors you want.

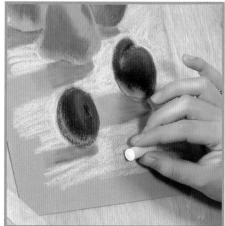

Be careful about where your hands are as you draw. Pastels spread very easily and you can accidentally spread them if your hand touches the paper.

In working with color, you have to consider the relationships between dark and light areas very carefully, so that you don't become confused between shading and color. Remember that objects present the full range of dark and light areas, in addition to their color. Drawing incorrect relationships between the tones is the main mistake that artists make when working with color.

You can see where the initial shading on the pears was drawn with a dark green, and that on the plums with a dark purple.

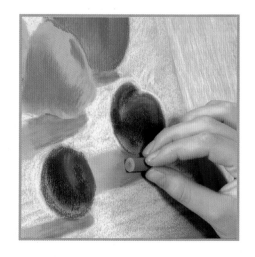

Keep comparing between light and shade, object and object, lighter area and darker area. Work on the entire surface of the paper at once, drawing the objects and the background. This is important, because you can only understand the tone in its surroundings and in relationship to other colors.

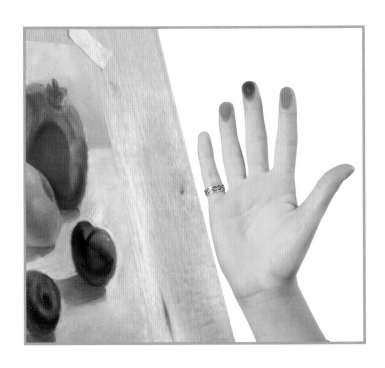

3

Once you've established the basic relationships, you can then concentrate on the color itself—mixing colors, putting hues on top of hues, spreading and blending with your finger.

I like to use different fingers for different colors, so that I don't have to wash my hands every minute. But be careful not to mix up your fingers and smear your drawing with the wrong color. (If this does happen, you can cover the area again with the right color, but it's better to avoid it from the start.) Every once in a while, it's a good idea to clean your hands with the cloth.

Let your imagination run wild and don't be afraid to follow your impulses. You can see, for example, where red was added into the green of the pears and ocher into the background and the shadow of the plums.

The important thing is not to lose track of the light and dark areas as you work with the colors.

You can make corrections with the kneadable eraser or the cloth, or simply put a new layer of color on top.

4

Notice that the original lines you drew have gradually disappeared and that colored areas have appeared in their place.

Continue working with the colors, making them cleaner and richer, and emphasizing contrasts.

If there are places where you've blended colors so much that they've become muddy, you can bring back both a cleaner and richer look by drawing hatching lines with the edge of the pastel. Yes, it works! You can see for yourself on the pears and the pomegranate in the drawing.

Above all, make sure you preserve the areas of light, shade, and returning light (the light edges caused by light bouncing off the table surface).

Don't forget that the background is an inseparable part of your drawing and deserves your attention. In this phase, the background colors were added to and deepened.

If your composition includes some detail, this is the time to draw it in with the edge of the pastels, as you drew the hatching lines earlier. Be careful not to let the detail stand out too much and detract from the overall picture.

As soon as the drawing is finished, carefully apply fixative.

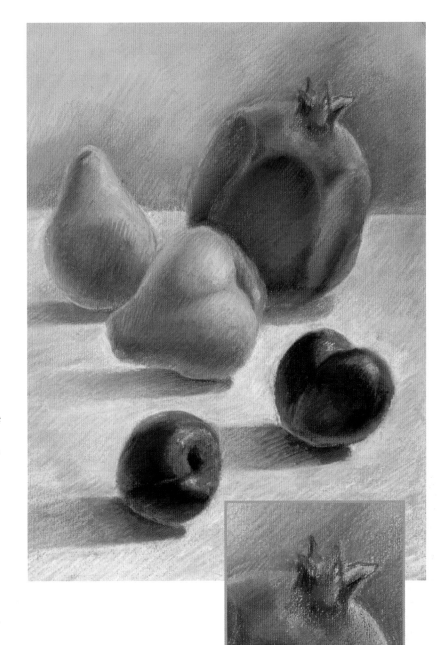

Drawing 9: Landscape

Now that you've got a feel for working with color, we'll try another drawing in pastels, this time a scenic view. I've seen my students take special pride in the bright, fresh colors of their pastel landscapes, and I hope that you will, too.

For this exercise, I chose a photograph of a meadow with warm yellow grasses and interesting layers of texture. I also like how the yellow of the grass contrasts with the blue of the sky.

If you're an outdoor type, take your set of pastels and head for a park or the open countryside. If you'd rather draw at home, just work from a photograph that you took or one that you find in a book or magazine.

What You'll Need

- Drawing board or easel
- Medium-textured paper (white or any color, any size)
- Set of soft pastels
- Soft cloth
- Kneadable eraser
- Fixative

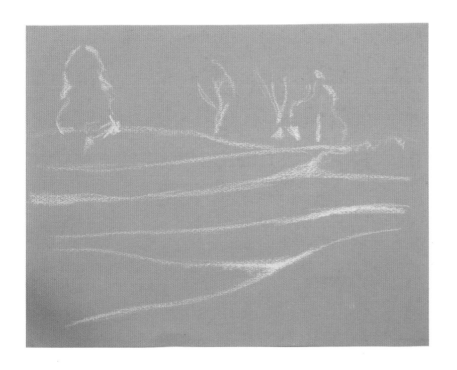

1

Look at your scene and choose a pastel to be the dominant shade for your picture. For this drawing, we selected yellow. Draw the main lines and basic elements of the landscape with this color. You can see, in this drawing, we marked the sections of the field and the placement of the trees. Keep your lines free and general—don't let the small details slow you down.

2

Start bringing your picture to life by drawing in the basic colored areas, gradually covering the paper. Watch out for differences in shade of the same color. For example, in this drawing, there are several shades each of yellow and green.

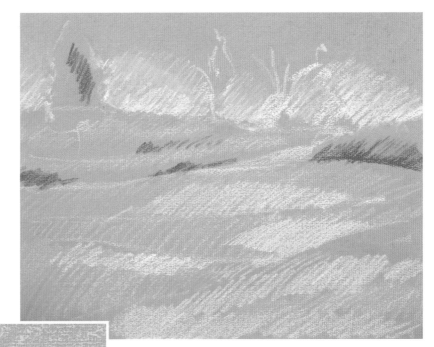

You can layer different-colored pastels one on top of the other in order to achieve the shades you want. (By the way, don't start blending yet!) In the lower left of this drawing, you can see where we began with a light yellow shade and then layered it with white and ocher.

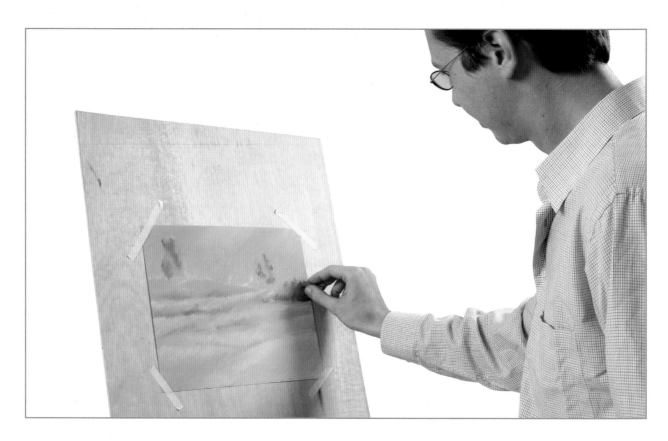

3

In this step, you'll improve and polish the colors. Up to this point, your drawing has been made up of main areas filled with layers of color. Now you can blend the colors in each area, using your fingers as you did in the first pastel drawing (page 103). To see an example of the effect you're going for, look at how blending has changed that same lower-left corner of this drawing.

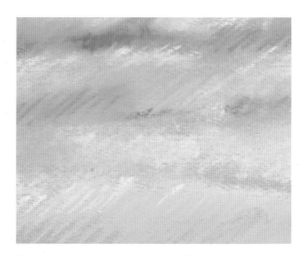

If you want to make corrections by adding additional colors, go ahead! That's what we did when we added green in the center of the field. Be sure to add additional colors carefully, though, so that you don't overload your paper with too much of the pastel substance. Try to reproduce the colors in your scene as closely as possible.

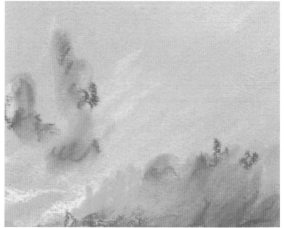

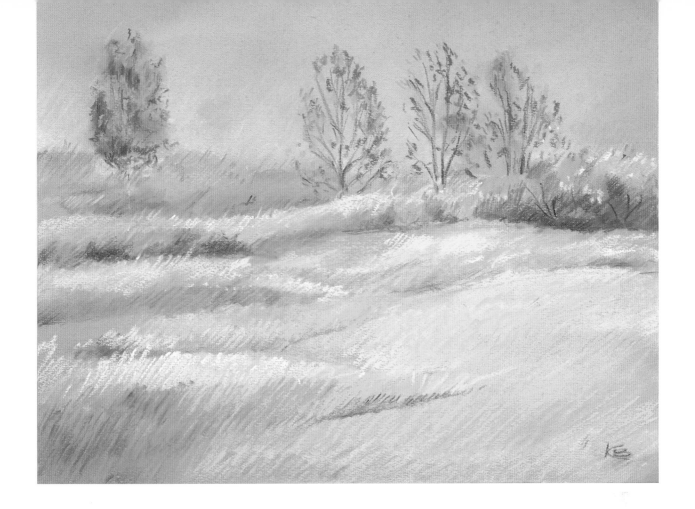

4 Your drawing has become more finished, but the colors are still very soft and devoid of contrast. The last stage is dedicated to building contrast and developing detail. Work here by drawing hatching lines with the edge of your pastel, as you did in our first pastel drawing (page 105). This prevents the new color from blending in with the previous ones.

With this technique you can create dark-colored areas, such as the deep-green grass in this drawing, which add contrast and richness to your picture. As you deepen the colors, they become cleaner and brighter. Your drawing gains depth and volume, and its features "come off" the paper.

Keep using hatching lines to create the texture of grass or other elements of nature, as in the corner of this drawing that you've been following, and to refine the small objects in your picture. With the point of the pastel, draw in details such as leaves and branches, and everything that you saved for now in order to work loose and free in the earlier stages of the drawing. You can see how we've brought out the bushes and trees in the upper-right corner of the field in this drawing.

When your drawing is finished, be sure to add fixative.

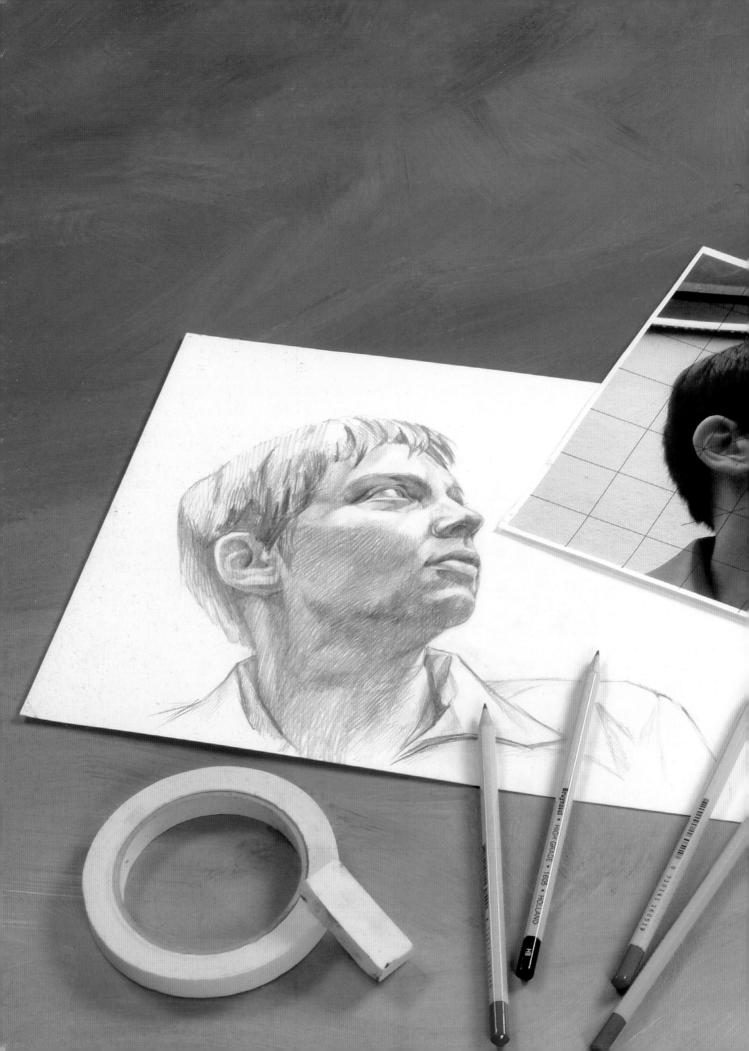

Going
Deeper

The portrait is one of the most captivating and difficult subjects in drawing: captivating, because we can actually commit a loved one's likeness to paper; and difficult because, if it doesn't resemble the subject, it can be very disappointing. If you're ready to try it, I can show you a tried-and-true method that delivers excellent results.

Drawing 10: Portrait in Pencil

What You'll Need

- Drawing board or easel
- Fine-textured, white paper (any size)
- Tracing paper
- HB and 2B pencils, well sharpened
- Colored pen
- Colored pencil, well sharpened
- Masking tape
- Ruler
- Kneadable eraser
- Normal eraser
- Photo of your subject

Our method involves using a grid to copy a portrait from a photograph and transfer it to drawing paper. You should enlarge your photo to the size of your drawing paper; if the details become blurred at that size, you should enlarge it to the largest size possible while still maintaining crisp, clear details. Your tracing paper should also be trimmed to the size of your drawing paper, if necessary.

While this may sound like a gimmick at first, it really isn't one at all. Artists have used this system for centuries: master portrait painters used to fashion grids with thread and a frame to observe their models through them, and mural painters use grids to reproduce small paintings onto vast surfaces.

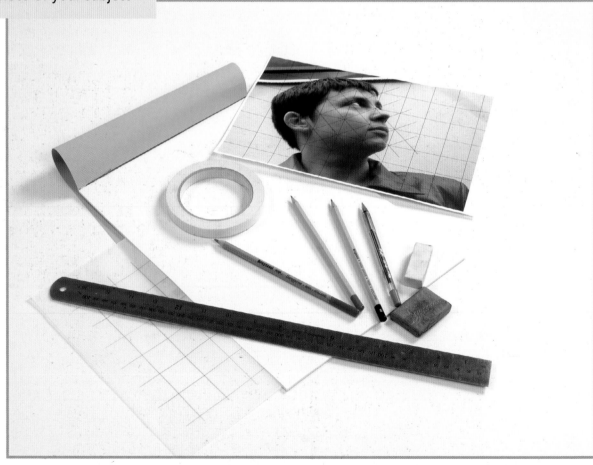

For this portrait, I chose a photograph that had very clear detail and obvious areas of light and shade. When you choose your picture, try to stay away from photos that were taken with a flash. These have practically no shading, just flat, uniform light. Choose an image that was taken as a close-up portrait. Faces in photos that were taken from a distance, or as part of a group, become unclear when you enlarge them.

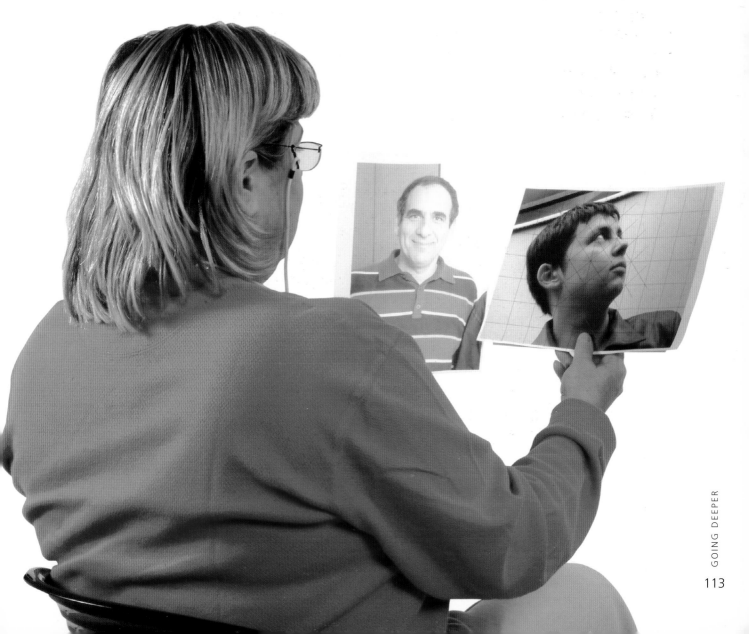

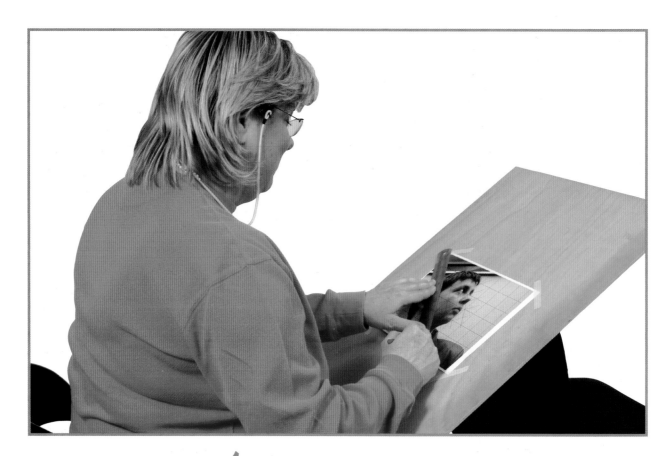

1 Divide your enlarged photograph into small squares using a ruler and a pen or pencil. If you want, you can add diagonal lines onto the more detailed parts of the photo, such as the eyes. This will break the squares into even smaller areas. You can see where this has been done on the picture.

Using the colored pencil, prepare an identical grid on the tracing paper with exactly the same lines and squares.

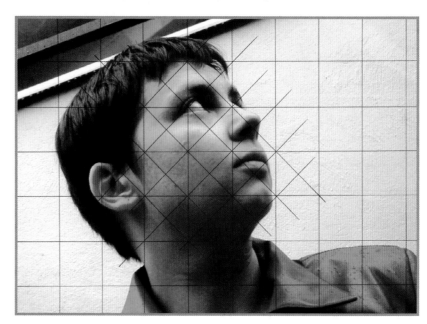

2

Still using the colored pencil, begin to draw (not trace!) the portrait on the tracing paper. Notice exactly where the facial features are in relation to the lines and duplicate this on the tracing paper.

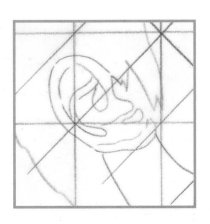

Draw slowly, line after line, always comparing with the picture, until you have transferred all the elements of the portrait.

If you need to make corrections, use the normal eraser carefully.

As you can see in this drawing, we've also drawn in some of the main outlines of the shaded areas.

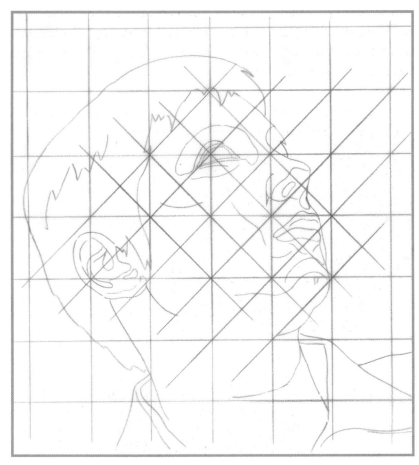

When you're finished, you will have a line drawing of the portrait on your tracing paper.

3

Now you'll transfer the portrait to your drawing paper.

First turn over the tracing paper and, using the 2B pencil on the back of the paper, completely cover the areas where lines appear. (Don't do this on your drawing paper! Lay the tracing paper face down on your drawing board or on a table.)

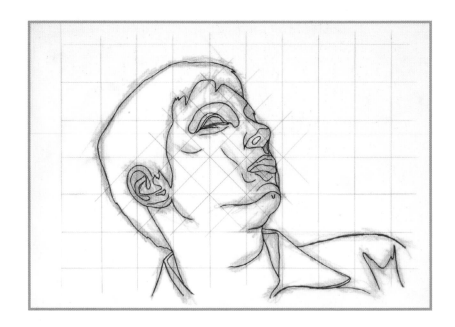

Now place the back of the tracing paper (the side that you just prepared) against the textured side of your drawing paper. Attach them together with tape at the top.

At this point, you can change your composition if you'd like. For example, if your portrait is off to the right of your tracing paper, but you would like it to be in the center of your drawing, you can place it over the center now before you attach it with the tape.

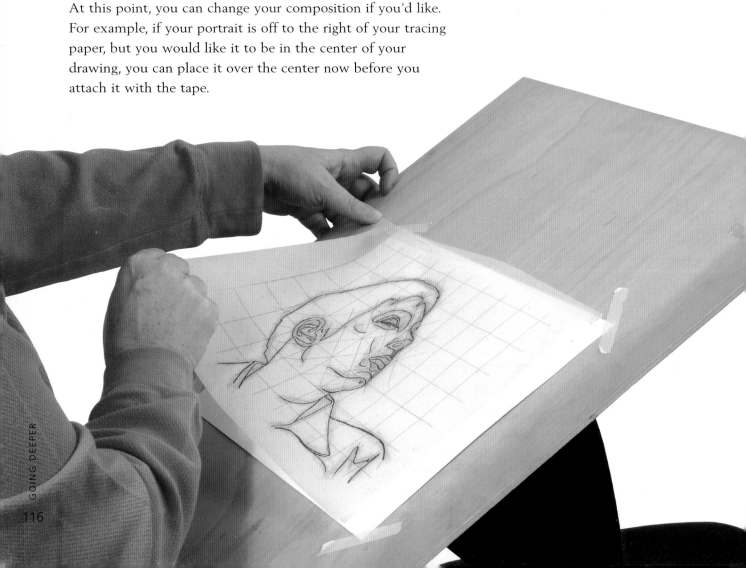

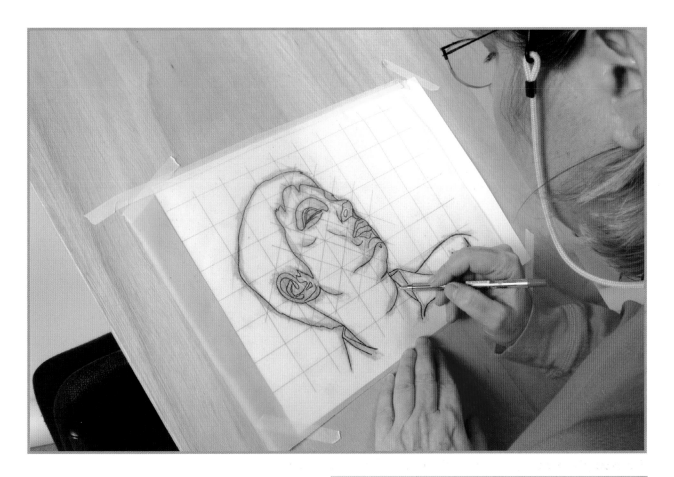

4

Go over the lines of the portrait with a colored pen. (The pen's color helps you see which lines you've gone over and which ones you haven't.) As you press on the lines, the lead on the reverse side of the paper rubs off and the lines of the portrait begin to appear on the drawing paper.

Try not to press too hard with the pen, otherwise you'll get an indentation on your drawing paper. You can lift the lower end of the tracing paper from time to time and check how the drawing is coming along, but don't do this too often, because you could move the tracing paper out of place.

Now your line drawing of the portrait, including outlines of the shaded areas, is on your drawing paper. If the lines came out too dark, you can lighten them with the kneadable eraser.

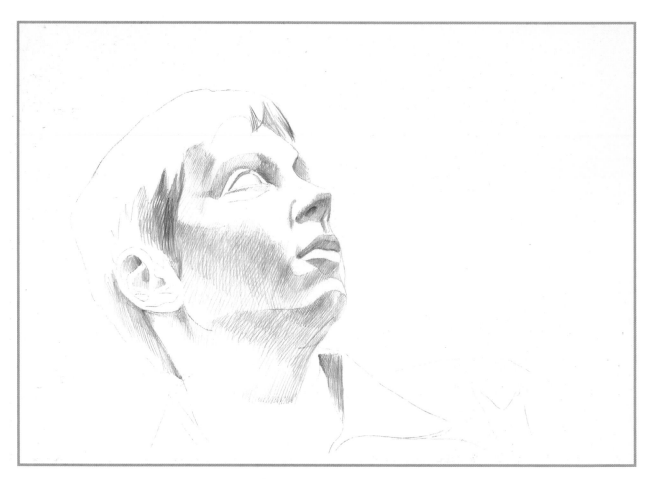

5

Begin developing light and shade. Draw the larger, most important shaded areas with an HB pencil, which will give the portrait volume. You can also carefully begin putting in the details, such as eyes, lips, and hair.

Remember that you can use the white of the paper itself for lit areas. As you work, your portrait will gradually change from a line drawing into a shaded one.

Keep comparing the drawing to the photograph.

GOING DEEPER

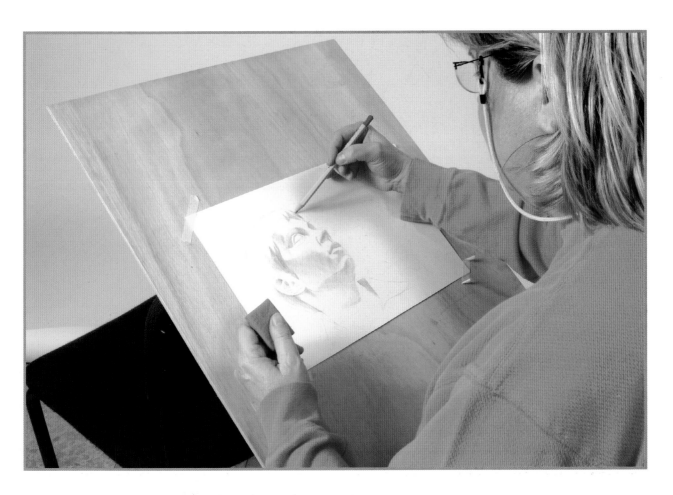

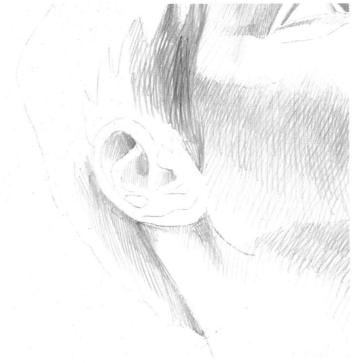

At this stage, it's a good idea to look at the reflection of the drawing in a mirror. Remember when you tried this in the chapter on charcoal (page 68)? If there is a lack of symmetry or some other inaccuracy in the portrait, you'll see it more clearly in the mirror.

Make your corrections carefully with the kneadable eraser. Don't erase too much, because you won't be able to redo the lines without smudging the drawing.

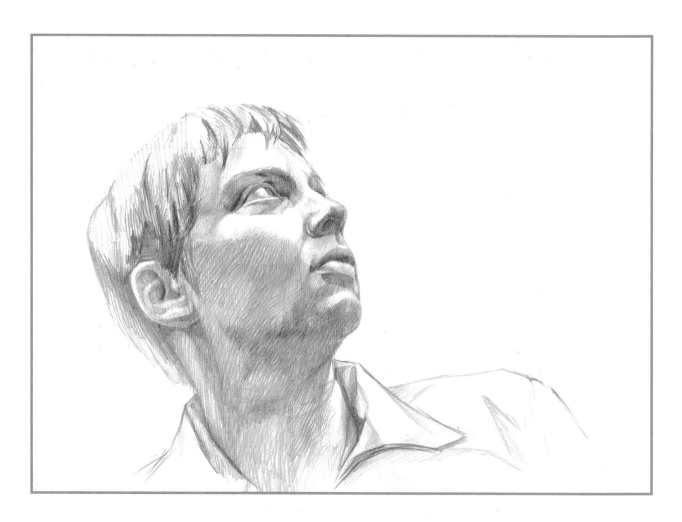

By now, you know what to do to finish the drawing. Blacken the darkest parts of the shading and emphasize the contrasts using the darker 2B pencil. If you wish, darken the background.

Draw in any remaining details carefully, without letting them stand out too much.

If you need highlights in places where you have drawn shading, create them using the kneadable eraser. Keep using the eraser to soften any borders between light and shade and to lessen the contrast where necessary.

Your portrait is finished. How does it look?

Drawing 11: The Human Body—Quick Sketches

There's no more challenging and exciting subject for an artist than the human body. As you probably assume, it's a theme of great complexity and one that can take a lifetime to master. So why, you may ask, have I included it in this book? I hope that we've come far enough together that you already know how I'll answer that question.

First of all, the drawings you've done have shown you that trusting your eyes, drawing what you see, and believing you can draw will take you farther than you ever thought you could go.

Second, the techniques we'll use for drawing the human body, like all those presented in the book, are simple and clear-cut. Even my beginning students have succeeded with them and been delighted by the results.

We'll make quick, spontaneous sketches that take only three to five minutes to complete. Our purpose is not to be exact or "correct"—the drawings are based on improvisation and trial and error. "Mistakes" are part of the process, so let your imagination run free, let your hand go wild, and just try!

My sketches were done using nude models, because that's the best way to see the differences among various bodies. Outside of an art school setting, however, you may not have this option. No matter! Just find models in the people you see around you in their many natural poses. You can do these sketches anywhere— in a coffee shop on a napkin, at the park in a sketchbook, or wherever you like to draw at home, using your family members as models.

These exercises are not divided into steps, and the sketches I've provided aren't stages of the drawing. They are simply various examples meant to guide you and give you ideas.

Exercise with Pencil and Straight Lines

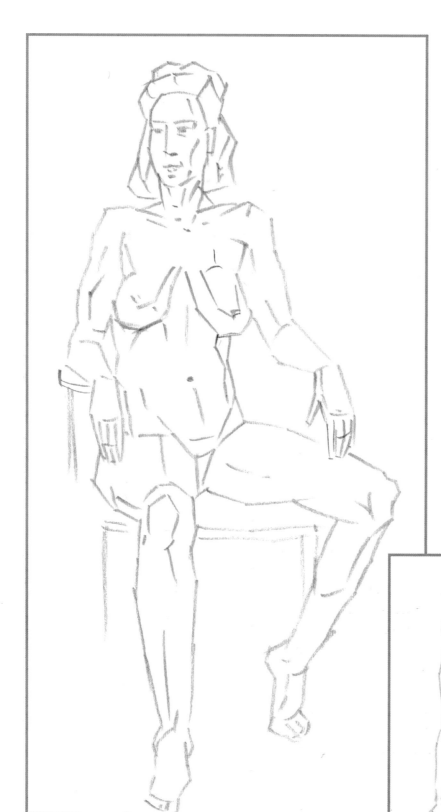

This method introduces you to the body's different parts and positions. The trick is to draw using only straight lines. Although the drawing may look hard and sharp, the exercise is valuable because it forces you to completely ignore any details and just connect the forms of the body.

Keep drawing continuously from beginning to end, finishing in three to five minutes. Try not to make any corrections with an eraser.

How did your first try turn out? It's not important—just go on and try it again!

Exercise with Pencil and Unbroken Line

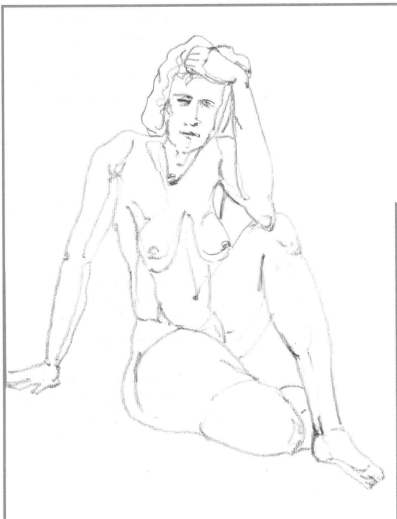

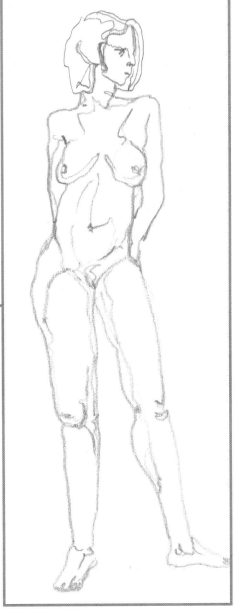

This exercise sharpens your perception and that all-important skill of drawing exactly what you see. Look at your model and draw your picture with one long line—without stopping and without lifting your pencil from the paper (and of course, without erasing).

Look more at the model and less at the paper, drawing "blind." Let your hand and your pencil move together and try to match the movements of your hand with the movements of your eyes.

When you're finished, look at your drawing and don't be surprised if it makes you a little dizzy. That's all right; try it again, and next time it won't seem to move around so much.

Exercise with Ink, Brush, and Quill Pen

When you first look at my examples, you might think that you're going to draw an outline with the pen and then "fill it in" with the ink. In fact, the technique here is exactly the opposite.

First use the ink (diluted to a gray shade) and the brush. With free movements, draw the basic areas of the body. Let the ink dry for a minute or two.

Now use the black ink and a metal or bamboo quill pen to draw the outlines of the body with quick strokes. The pen lines won't always follow the brush marks exactly, but that's precisely what makes your drawings unique and personal.

Remember, give yourself only a few minutes for each drawing, and try as many as you like!

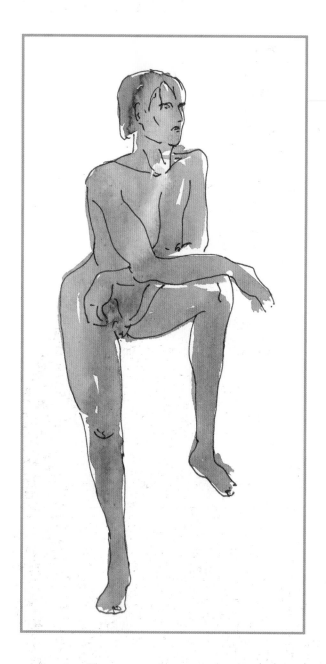

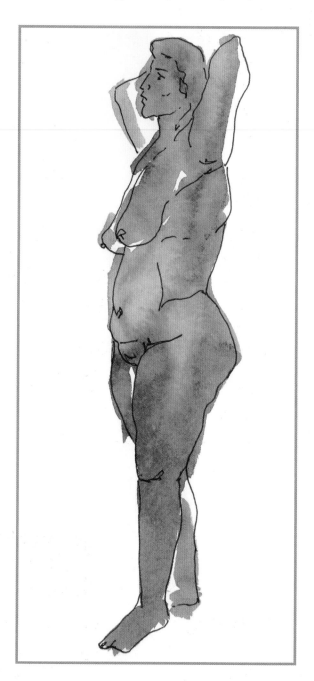

Exercise with Ink and Brush

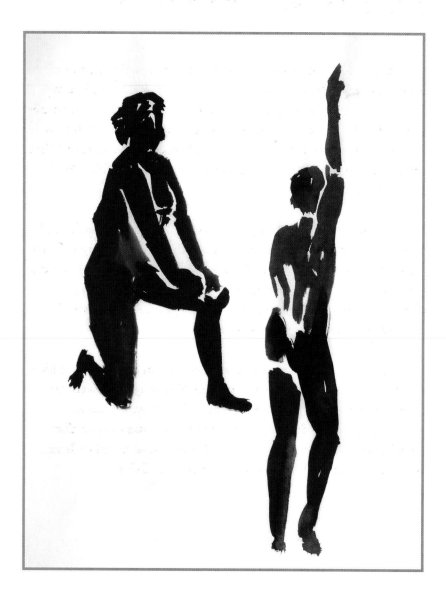

For these sketches, don't allow yourself those generous three to five minutes. They should take two minutes at the most!

This exercise trains you to notice the "movement" of the body and how it changes from position to position. Draw your model in different poses, using only straight lines. Notice the changes in direction and the angles between the parts of the body with each pose.

Don't take time for light and shade, even though the ink and brush technique allows you to draw these elements. Just capture each new position quickly, then move on to the next.

A Final Word

Admit it, revel in it—you can draw! I hope that this book has encouraged you to keep on learning at your own pace. You've discovered a new way to see your surroundings and found scenes that cry out to be drawn. Stay curious and approach each new composition as if you've never seen it before. Ask yourself: What shapes do I see? Where are the areas of light and shade? And always trust your eyes.

Most of all, remember that you'll absorb the drawing skills and techniques I've presented here as you go along. Drawing is not a test—it's about your eyes and your feelings. Concentrate on your subject, not on your drawing, and be assured that making mistakes is fine. In fact, trial and error is the only way you'll improve and develop your own style.

Consider going back and using this book in any order you'd like to practice drawings that you enjoyed. You may even want to continue beyond that, either on your own or with a class. Whatever you decide, I hope that your understanding of the world and of art has been enriched by our time together here. Now close this book, pick up your pencil, and draw!

Index

B

Background 32, 67, 81, 85, 102, 105

Blending 22, 65, 73, 83, 84, 103, 108

Brushes 14, 17, 27, 92, 96

C

Charcoal 15, 17, 22, 23

Contrast 61, 68, 73, 82, 85, 93, 109, 120

Cross hatching 29, 42

Cube 51, 57–58

Cylinder 52–53, 58

D

da Vinci, Leonardo 24

Degas, Edgar 29

Drawing board 18–19, 35

E

Easel 18–19, 35

Ellipse 52–53, 58

Erasers 15, 22, 44, 45, 67, 69, 84, 101, 117, 120

Erasing 22, 44, 45, 82, 90, 119

F

Fixative 14, 23, 29

Frames 14, 35–36, 41, 49

French art 24, 25, 29, 78

H

Hatching lines 42, 43, 44, 45, 105, 109

Highlight(s) 44, 69, 84, 120

Horizon line 47, 48, 50–51, 57, 72

I

Ink 14, 17, 26, 88, 89, 90, 91, 92, 93, 96

Black India 26

Chinese 26

Dry 14, 26, 91, 93

Liquid 14, 26, 91, 93,

Ink stone 14, 26

J

"Just for Fun" 11, 29, 36, 55, 75, 84, 94, 120, 125

K

"Key to Success" 43, 61, 68, 73

L

Light

and Shade 23, 29, 42, 45, 60, 63, 66, 67, 82, 102, 113, 118

Direct 69

Lighting 34

Returning 60, 105

Lightening 22, 44, 45, 67, 69, 82, 84, 93, 94, 101, 117, 120

Lines

Horizontal 50–51, 54, 57–58, 72, 80, 92

Parallel 50–51, 57–58

Straight 50–51, 52–53, 54, 79

Vertical 42, 51, 58

M

Michelangelo Buonarroti 24

P

Paper 16–17, 29, 90, 100, 108

Pastels 17, 22, 28–29, 102, 107, 108

Pencils 15, 17, 20–21, 22

Perspective 46–54, 57–58, 90

Rules of 54

Portrait 113

Proportions 37–41

Measuring 38–39

Q

Quill pens 14, 27, 97

R

Raphael (Raffaello) Sanzi 24

Rembrandt Van Rijn 77

Renaissance 24

Rubens, Peter Paul 77

S

Sanguine 15, 17, 22, 24–25

Sepia 15, 24–25

Shading 42, 43, 44, 45, 59, 66, 67, 68, 73, 75, 81, 82, 92, 93, 96, 97, 102, 109, 118

Rules of 60–61

Shadow 41, 43, 66, 80

Still life 32–36, 55

Common mistakes of 33

T

Tortillon stumps 15, 22, 73, 83

V

Vanishing point 47, 50–51, 57

Viewpoint 35–36, 47, 49, 51, 72

Corner 51, 57

Eye level 52, 54, 57, 72

Frontal 51, 57

High 49, 52–53, 54, 72

Low 49, 52, 54, 57, 72

Volume 81, 82, 109, 118

W

Watteau, Antoine 25

White chalk 15, 17, 24–25